WATERCOLOR

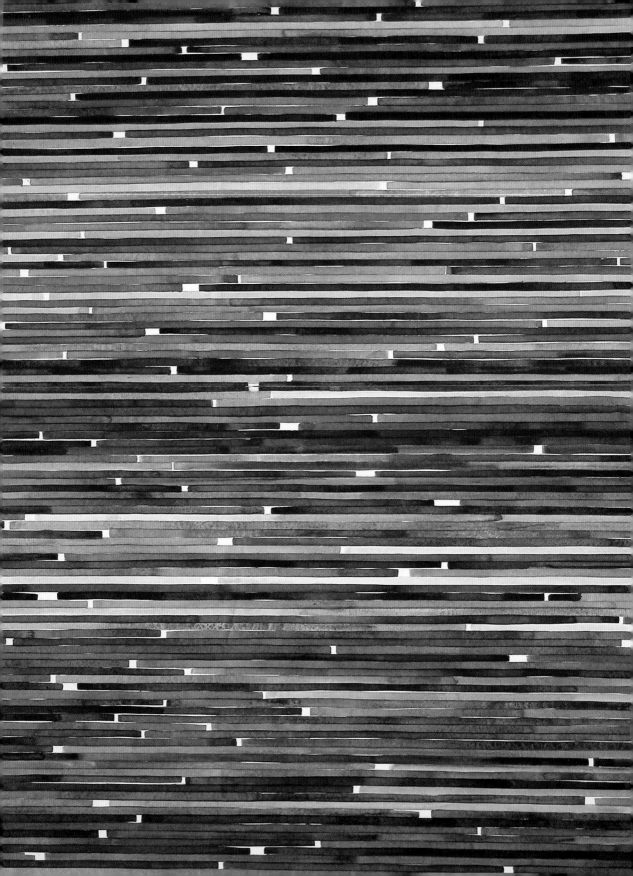

WATER COLOR

PAINTINGS BY CONTEMPORARY ARTISTS

PREFACE *by* SUJEAN RIM
INTRODUCTION *by* LESLIE DUTCHER

CHRONICLE BOOKS
SAN FRANCISCO

Book design by Neil Egan
Additional typesetting by Liam Flanagan

Library of Congress Cataloging-in-Publication Data available.

ISBN: 978-1-4521-1264-0

Manufactured in China.

Inside covers: artwork by Dear Hancock.
Page 2: artwork by Amy Park.
Pages 2, 88–95: artwork courtesy of Morgan Lehman Gallery, NYC
Page 4: artwork by Samantha Hahn.
Page 12: Photo by Lori Cannava 2011.
Pages 154, 155, 158: Photos by Kevin Noble.

10 9 8 7 6 5 4 3 2 1

Chronicle Books LLC
680 Second Street
San Francisco, CA 94107
www.chroniclebooks.com

CONTENTS

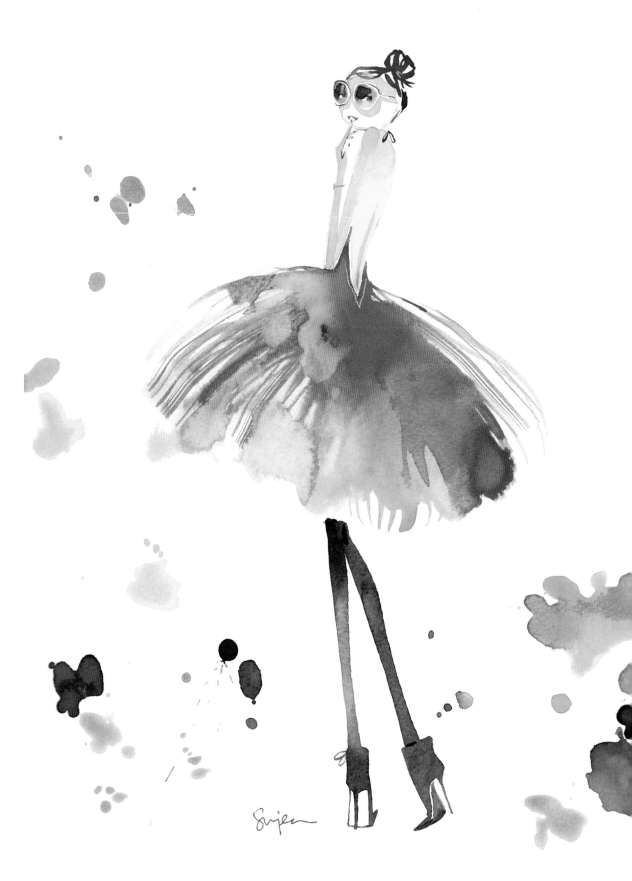

Preface

by Sujean Rim

Watercolor is such a flirt.

The way it suggests form with sheer washes of color. The way it plays with light and depth with splashes of water. The way it can tease the eye by capturing realism until you notice shapes bleeding.

With watercolor, there are no perfect lines. There are many fewer rules than with other art forms, and there is no time to overthink. Once your wet brush hits dry paper, you're done—and there is no undoing what you've committed your brush to. And no matter what bag of tricks or techniques you may have developed, you are never quite in complete control.

As an artist, it can feel frustrating to not have that control. But if you allow watercolor to just do its thing—and stay open to those inevitable happy accidents, whereby colors leak into each other or your brush runs dry in the middle of a stroke—the most beautiful things can happen. The not-always-knowing-what-to-expect feeling that this medium sparks is what I find the most fun—it's what keeps me curious. You may never truly get to know your watercolor, but you can flirt back.

My first encounters with watercolor were probably much like yours. Childhood memories of painted fingers, splattered smocks, rolls of white paper, old coffee cans full of dyed water, and fat friendly brushes come to mind. It was fun, but I wasn't all that smitten just yet. Crayons, glitter and glue, and Play-Doh were just as impressive.

It wasn't until I watched my father ceremoniously take out an old handsome lacquer box of *sumi-e* black ink and beautiful bamboo brushes that I really took notice. He would paint Korean and Japanese calligraphy onto soft and translucent white paper with this incredible black and syrupy ink. I could feel his thoughtful concentration. Each brushstroke was confident and each had purpose. When I asked if I could *pleeaasse* try those awesome brushes and ink, I was always turned down and told, "Someday." I knew they had to be something special.

I later took closer notice of the old Korean landscape paintings around our house. They were on pretty silk scrolls

Flirt, 2012
Watercolor
14 × 12 in. (36 × 30 cm)

7

hanging from wooden dowels. You probably have seen something similar at your favorite Asian restaurant. No matter the quality, I found these images of mountains, water, and nature to be increasingly beautiful, and I started to wonder, "How did they do that? How did they paint those peony petals to look so real and delicate, or those mountains to look so grand?"

Soon I would come to admire more styles of watercolor. Among my first inspirations was Charles Schulz (yes, the creator of the cartoon dog Snoopy). I received a big art book of his work that showcased some of the beautiful watercolor backgrounds he painted for his comic strip, *Peanuts*. These artworks, like the Asian ones I had grown up with, also employed visions of nature.

Whether it was an autumn scene with piles of colorful foliage or a snow-filled winter landscape, each depiction captured so much feeling, yet with little detail. These paintings appeared so loose in their renderings. You could see droplets of water, you could see gradations of color blending into each other. And the use of the negative space of the paper fascinated me—a small unpainted area in a wash of blue suddenly became a cloud in the sky.

In art school I was able to experiment with lots of media. I tried oils and acrylics, but I felt lost and overwhelmed in the world of linseed oils and varnishes. I would always come back to watercolor. And I still return to it—maybe because of the simplicity of needing only water to paint, or maybe because I simply love to sketch.

I love the spontaneity of capturing an image. It is pure, honest energy and emotion—there's no struggling, no worrying for perfection in a sketch. Painting with watercolor has that sense of immediacy—you are working with wet and running color, so you have to get your brushstrokes down quickly. There's not much time to think or agonize, so in the end you hopefully can just enjoy the ride.

When asked what medium I use, it is not surprising to hear, upon giving my response, a polite "Oh, watercolor. That's so sweet." Or "Now, I have a friend who paints with *oil*." Maybe it is because we have childhood memories of those splattered smocks that I mentioned before, but to those who question watercolor's sophistication, I would have them take a look at works by Winslow Homer or Andrew Wyeth. For breadth of style, I say look at Charles E. Burchfield, J. W. S. Cox, Mats Gustafson . . . and just take a look at this book.

I'm certainly smitten.

Introduction

by Leslie Dutcher

Watercolor is a felicitous and spontaneous medium. Notoriously unforgiving, it works best for artists who strike a fine balance of skillfully harnessing its unpredictable character and gracefully accepting its chance-like meanderings. The combination of both this control and this letting go has given the medium its freshness—the sense that its images are always on the precipice of blossoming or dissolving, each held in one fleeting moment of time. The good watercolor is, perhaps, a mere visual record of its becoming.

Watercolor is also an intimate medium; its tools (brushes, a small palette, and pigment tubes or cakes) fit in a knapsack or even a large pocket, and the artist can cultivate his or her inspiration just about anywhere—on a city park bench, at a café table, or on a train. This has made the medium popular to Sunday painters, documentarians, and the obsessively driven alike. It has also made it favorable to young children, who include a tray of watercolor paints and a brush among their first school supplies.

While often shadowed under the more "serious" medium of oil painting, watercolor has proved to be as elegant and academic as its counterpart, while retaining its own ebullience and congeniality. In the twentieth century especially, the medium achieved "high art" status in works by artists such as Wassily Kandinsky, Paul Klee, Egon Schiele, and Joseph Beuys. Contemporary artists, from Anselm Kiefer to Gerhard Richter, have also employed the medium in some of their most colorful pieces.

The medium of watercolor, by simple definition, is that in which paints or pigments are suspended in a water-soluble medium, bound by an agent such as glue, casein, or gum; the word *watercolor* is typically reserved for transparent washes, while opaque watercolor is called *gouache*. Today we know the paint most commonly in its manufactured form, whereby the pigment is bound in natural gum arabic and honey or glycerin to increase its plasticity and the ease by which it is dissolved. Prior to this concoction, "watercolor" existed in various other forms,

Watercolor spots by Samantha Hahn

including tempera, distempera, and water and ink. Historically, other water-bound pigments have included vermilion, ocher, malachite, and other earth colors; pigments have also been made from sources as unexpected as dried cochineal beetles and the ink sacks of squids. We associate watercolor most readily with works on paper, but the medium, in its many historical variations, has graced other supports including silks and other fabrics, parchments and vellums, and wood.

Watercolor, because of the easy accessibility of its two main components—water and pigment—has an old history, long predating oil and acrylic paints. Two-dimensional impressions made by water have perhaps always existed in nature: the design of a dried-up puddle, the elegant streaking on the side of a cliff. Intentionally mixing this element with color to form human works of art has historical precedents throughout the world. Ancient Egyptians used water-based paints to ornament the walls of their temples and tombs, and they created the earliest known version of paper by utilizing papyrus, a reedy plant whose inner pith was beaten together, dried, and polished to form a single smooth sheet. Painted icons have long been colored in distemper on murals and church walls in Ethiopia as well as on metals, woods, and goatskins. In India and Persia, opaque gouache was used in paintings to depict stories from their histories and religions; and tempera was utilized in ancient and medieval Indian caves and temples.

Chinese and Japanese painters are generally regarded for their created ink-and-water works of calligraphy and landscape on silk and fine handmade papers, and for their mounting of such supports onto rods to form scrolls. The earliest known paintings in China reveal basic patterns and designs, which gave way to later representations of the physical world. These underpinnings led both to calligraphy and to a legacy of depictions including human figures, contemplative landscapes, narratives, and "simple subjects" such as flower blossoms, animals, or pieces of fruit.

Traditional Chinese water-based painting has been found on walls, pottery, lacquerware, and folding screens. Importantly, however, in the second century C.E. paper was invented in China. Possibly inspired by the nest materials of wasps, a kind of paper similar to what we know and use today was first made from tree bark, hemp remnants, cloth rags, and fishing nets. In the ensuing centuries, the knowledge of papermaking began to spread outside of China, first to Korea and Japan, then to the Arab world and India, and to Europe.

Watercolor painting in the West is believed to have originated in European caves of the Paleolithic period; these early artists used fingers, stones, and branches to execute their water-and-pigment depictions, often of animals. Panel painting was highly prized in ancient Greece and Rome, and tempera-painted examples can be found from as early as the first centuries of the Common Era.

Versions of painted manuscripts date to Roman times, but most surviving examples are from the Middle Ages. European monks used tempera—often in combination with silverpoint, gold or silver, and ink—to decorate their illuminated manuscripts. Their pages were detailed with scrollwork, border decorations, gilding, and symbolic iconography, often on parchment or vellum made from lambskin, kidskin, or calfskin.

The first paper mill in Europe was established on the Iberian Peninsula in the mid-twelfth century, and substantive paper manufacture in Europe began in the second half of the thirteenth century in Fabriano, Italy—at a factory that continues today to produce papers and can be toured by connoisseurs and lovers of paper. Papermaking in Europe laid the base, quite literally, for watercolors that began to resemble the art form as we know it best today.

Although Renaissance artists initially employed watercolor for colored maps, zoological and botanical illustrations, or as studies and cartoons for paintings that they would later execute in oils, some used the water-based medium to create substantial works of art. Among them, the German artist Albrecht Dürer and the Flemish artist Hans Bol created watercolor works of observational acuity and mystical ambience.

Watercolor underwent further explorations and innovations in Great Britain during the eighteenth and nineteenth centuries. Prior to such time, watercolor artists had purchased their pigments from apothecaries or "colormen," and such pigments were provided as hard, dry clumps that were difficult to break down into a soluble form. As a result, artists concocted various, sometimes laborious, methods alongside secret recipes for formulating their paints.

In 1766 William Reeves began to manufacture his own paints in a basement workshop and displayed the colors in his store windows. He made and sold the first dry-cake watercolors, and in 1780 he applied honey to his paints, making them more moist and pliable. William Winsor and Henry Newton, in 1835, introduced glycerin to their watercolor cakes, further softening the pigment; and in 1846

they again modified the formula, creating the first watercolor paints available in tubes.

These developments made watercolor accessible beyond a snug sphere of artists, expanding to hobbyists, watercolor societies, and finishing-school ladies alike. It is purported that Queen Victoria even sent carriages to the Winsor & Newton store to pick up paints for her studies. Other developments were made in the chemistry of pigments, creating a more vibrant palette for the painters of the time—most especially the Pre-Raphaelites who dabbled in the medium—and resembling more closely the colors we associate with watercolor art today.

Outside of its salons and societies, nineteenth-century Britain elevated watercolor painting in the art-historical canon through some of the greatest artists of the medium. Among them was Joseph Mallord William Turner, whose ravishing and layered watercolor landscapes easily rival the works that he and other artists made in oil.

Watercolor also began to flourish in the United States at this time. The ornithologist and painter John James Audubon made 435 preparatory watercolors for his book *The Birds of America* (1827–1838), still a respected work on the subject. The painter Thomas Moran's watercolors, made during the artist's visit to Yellowstone in 1871, were presented to the U.S. Congress

as part of the successful campaign to designate it as America's first national park in 1872. In the twentieth century, one of America's best-known painters was the realist Andrew Wyeth, who worked primarily with watercolor; his *Helga Pictures*, comprising many watercolor pieces, are arguably some of the most iconic works in recent art memory.

* * * * *

The artists showcased in this collection are among the most interesting and exuberant watercolorists working today. While they draw upon the medium's historical themes and processes, they also extend that history into the contemporary backdrop, which includes the clatter and barrage of a media-driven world, neo-surreal morphologies, postmodern shifts and collaging, technological isolation and its denatured environment, and the subsequent layering of narratives and meanings that infuse our daily existences.

In our Internet era, watercolor has proven itself an adaptable medium for the backlit computer screen. It illustrates blogs and websites with much of the same vibrancy it achieves on paper. Also, because of its small scale, watercolor art can often be shown life-size on the glowing monitor. Consequently, online galleries and shops have been able to appropriately highlight the medium to collectors and buyers, and the artists' works are easily moved from the paint-splattered studio table onto a worldwide stage.

Sujean Rim, whose background includes fashion illustration, has also illustrated children's books and previously she decorated the popular email newsletter *Daily Candy*. The handmade quality of her watercolors lends a human touch to the graphic sterility of type and design that characterize much of the Internet's aesthetic; each morning, readers of *Daily Candy* were welcomed with bright red apples, chirping birds, stacks of books, and swirling goldfish, among other renderings so fresh as to still appear wet on the paper upon which they were made. In Rim's other artworks, elements from fashion emerge: stylish handbags, poufy party dresses, boxes stamped with designers' names. Perhaps never before has a pair of stiletto heels been depicted with such capricious delight (page 111).

Samantha Hahn, another illustrator, also integrates fashion in her watercolor works: fancy ladies, Warholian perfume bottles, beribboned hats. She too depicts simple details from life: a spunky French bulldog, butterflies and dragonflies, meringue topped with pomegranate. Hahn is also virtuosic in her use of

color: brightly clad characters stroll through contemporary urban backgrounds in her renderings displayed on *Daily Candy*.

Another illustrator working in the theme of fashion and everyday detail is Julia Denos, whose images include pretty patterns, ballet flats, and a variety of vegetables. In one depiction of a cut-open beet, watercolor is employed to capture the matching essence of a beet stain (page 33); in another, the bleeding green paint creates the natural gradation of color in a head of lettuce (page 35). Denos has created her illustrated images for advertising, books, and magazine covers.

A woman in an elegant black ball gown is among the works of Virginia Johnson, a textile artist who also creates watercolor artworks. Design motifs from her fabric prints appear in some of her watercolors, some as direct depictions of such designs, others as design elements that work within more representational compositions. In one image, *Potted Fern*, a woman stands against a patterned background, but because the woman is painted with lines and shapes similar to what lies behind her, she becomes entwined within the design (page 55). This creates a dynamic struggle and a balance between abstract design and representational elements, which may be an aspect of a watercolorist's process—to make from randomness an objective form.

The women in Cate Parr's paintings are also held in the delicate webbing of human depiction and painterly flourish. Her subjects, often celebrities, appear inflamed in vivid streaks and washes; some look placid, even trapped, within the brushstrokes, while others seem to resist. Compellingly, and through her alchemy of the watercolor medium, the artist transforms the media photography of such famous persons as Charlotte Gainsbourg, Daphne Guinness, and Jeanne Moreau by restoring a psychological reality to each of the painted subjects.

Daire Lynch also creates portraits of psychological intensity. Unlike Cate Parr's glamorous women pulled from the pages of fashion magazines, Lynch's subjects seem drawn from street corners, family photo albums, high-school yearbooks, or the back rooms of bars and parties. His sitters, painted primarily in French ultramarine, do not necessarily exude the melancholy we have perhaps come to associate with the color blue. Instead, Lynch's depicted humans seem contemplative, even yearning, balanced on the edges of many possible emotions; this not-one-dimensional interpretation is perhaps the most accurate rendering of any model or person—

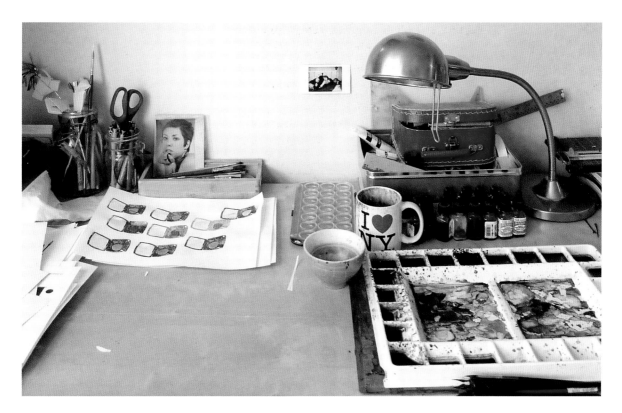

and watercolor, which can run in any direction at any moment, serves as an appropriate medium.

Samantha Hahn's worktable

It is tempting to imagine in Amy Ross's surreal work that the spills of watercolor lead to depictions not otherwise thought, thereby inducing a world different from the one that nature supplies. The artist's painted humans begin to blur into other forms in her tightly rendered work. Some of Ross's subjects mask their faces by holding up leaves or flotsam; others seem wholly transformed with wolf heads atop their human bodies. These partial humans seem to approach their otherwise normal natural environments with both caution and curiosity, as though reality is something strange to these beings who, at least in one painting, are of question to an onlooking dog (page 123). Elsewhere in the artist's works, more strange things occur: birds appear to grow from trees, woodpeckers sprout mushroom heads (page 122).

Isadora Reimão also works with morphing beings. *Pumpkin Charles* sports an enlarged and oddly shaped ear along with science-fiction tubing and mechanical apparatuses. *The Caterpillar* bears the top portion of a human female. Reimão experiments in other media as well, and some of her enigmatic creations have been further transformed off of the watercolor page, turning into three-dimensional sculptures, puppets, and film characters.

Animals also abound in the work of Hannah Ward. The artist makes use of the light paper beneath her colors to capture the glowing face of a deer or the lit spine of a wolf. She lets the pigment run freely from the finely rendered bodies of slain game to depict the blood that streams from them, thereby heightening the violence that is otherwise more quietly implied in their representations (page 166).

Another animal, a bleating deer, commands attention in one of Paolo Terdich's watercolor compositions. This image, among others of the artist's lush and colorful works, demonstrates a layering effect that can be achieved in watercolor to reproduce highly realistic works. A series of Terdich's works, *Waters*, comprises paintings of swimmers in light-splattered water made in oil, acrylic, and watercolor, effectively showing how the three media can provide similar representation.

Jane Mount has also created a menagerie in her watercolor depictions. In her series *26 Animals!*, she imbues some famous animals with human traits: the tiger, Ming, moves from his Harlem apartment to live on a farm in Ohio; the space dog, Laika, views the earth from *Sputnik II* and finds it beautiful. A separate painting, *132 Birds Leaving the AMNH* (pages 82–83), readily harks back to the work of Audubon, showing that watercolor

Dear Hancock's worktable

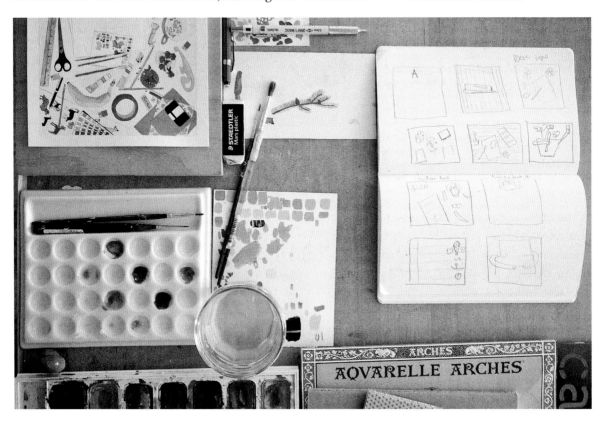

is still a viable means of depicting the natural world with new lustrous colors.

Danny Gregory also uses watercolor to create series of detailed artworks, most notably in his "illustrated journals," some of which have been turned into published books. Drawing from the tradition of illuminated manuscripts, Gregory's journals find transcendence in the everyday world around him, which is easily reflected in the versatility and "go anywhere" aspect of watercolor. Following loosely the monks' traditions, he ornaments his pages with titles, words, sidebars, and other design devices.

Because the watercolorist can turn to his or her tools so easily, the everyday is a common theme, found in many of the works in this book. Becca Stadtlander paints an overgrown garden, dinner seen through a restaurant window, a cozy salon, and a field of goats. The medium, with its small brushes, enables both the simplicity and the detail that her paintings exemplify. Recently her art, which adopts themes of domestic life, has appropriately been showcased on the cover of the *Saturday Evening Post*.

One can almost imagine stepping out of Becca Stadtlander's painted parlor into the corridors depicted in Tamara Thomsen's artworks. Thomsen's rooms, as well as her landscapes, give the viewer the perspective of being fully immersed in their spaces—in fact, her watercolors are unusually large, some nearly wall-sized. They further evoke the palette and sparseness of a van Gogh painting—the post-Impressionist painter also worked in watercolor and created many distinctive works less textured than the oil paintings that most associate with his œuvre.

It is likewise easy to picture Anna Emilia Laitinen bent over her paints and papers as she creates her intimate and fastidious works. Like some of the other artists collected here who depict metamorphoses of persons to animals and animals to persons, perhaps as a means to reconnect with a lost nature, she makes similar transformations between interiors and exteriors, including a forest tearoom, a birch village, and an island bed. The delicacy of watercolor, which can enable a feather-softness in its execution, is well suited to Laitinen's subjects and themes. She has even used melancholy thistle flowers as paintbrushes.

Dear Hancock, a husband-and-wife team, has extended the intimacy of watercolor into a business of paper goods, including greeting cards, prints, and other stationery items. Written letters, similar to watercolor art, are about the work of the hand, which sometimes seems lost in an age of technology and mechanical reproduction. Handmade watercolor cards have long been made by children, valentines, and artists alike; and Dear Hancock, like

many other contemporary art businesses, has made its artistry available to those who also wish to retain the quality of the hand in the art of written correspondence. The image *Creative Workstation* details the watercolor artist at work, complete with palette, mixing tray, and brushes (page 27).

Fabrice Moireau has created cityscapes and country landscapes from life with a surprising intimacy that we usually associate with interior depictions. He has painted Rome, Paris, Provence, Venice, and other locales; and his sketchbooks, some of which have been published, capture these places with both acuity and heart. His buildings and scenes are often, although not always, without human occupants, and yet they feel welcoming and embracing. It is as though the human presence is not far, somewhere receiving the signals from the antennae of his Paris rooftops, or just behind a drawn curtain in a window of one of the mansard-roofed buildings. Moireau's paintings even evoke those senses that cannot be captured in the painted composition: voices in the distance, food fragrances wafting from café doorways, lovers kissing somewhere. Or perhaps the human is felt in the gestures of his brushwork and the raw, handmade quality of watercolor.

Watercolor may also show less of an artist's hand, as Amy Park's work documents. Her paintings of architecture, like many of Fabrice Moireau's, are devoid of humans, but with differing effect. Her hard-edged, industrial buildings with façades of duplicating windows or mirrors record spaces made and inhabited by humans, but none of the human softness is found. Her buildings are gigantic, omnipotent; stacks of bricks and balconies seem never-ending. In her work, the architects Alvar Aalto and Oscar Niemeyer are present, but the painter Edward Hopper is present as well, in scenes of urban loneliness. Park's work appears abstract in the way she determines the crops and distances of her compositions; her great buildings merge, even disappear, into repeating patterns and color formations.

Patterns and color formations frolic in John Norman Stewart's abstract watercolors. The painter, who also works in a representational mode depicting landscapes, seems to have broken down the shapes and colors of the land and sky into these abstractions that, unlike the seemingly immutable landscapes, appear to be in perpetual motion. As Stewart is a musician as well as a painter, it is not surprising to note in his work similarities with that of Kandinsky, who strived to depict music in some of his abstract paintings.

Jenny Vorwaller's painting *Chance* documents how the watercolor medium's random nature can be utilized to create, with an artist's thoughtful intervention, evolved compositions (page 162). Vorwaller builds out of the random parts of this painting a vibrant image that resembles color bursts or a bouquet of flowers. In another of her paintings, *Reflection*, the subject is more defined, but aspects of abstraction and a bit of chance are still employed (page 160).

José Seligson has created his often abstract watercolors using unorthodox tools such as spray bottles and syringes, and he has experimented with nonporous paper, unusual for watercolor, which more commonly soaks into a dense, textured paper made for such purpose. In his paintings, blocks of paint become quilt squares and long sinewy drips become blood streams; a collagelike effect of layered and painted colors is titled *Traffic* (pages 126–127). With his metaphors and paint applications, Seligson allows many of his watercolors to become works of art out of their own seemingly transformative happenings.

Watercolor today draws from its rich history to create a postmodern cacophony of diverse themes, processes, and images. In our historical present, the drips and spills of watercolor have run into multifaceted abstract and representational images, each artist moving his or her paintbrush to depict each's own iconography and reality, be it documentary in nature or imagined.

Looking through the lens that is our twenty-first-century moment, these artists reflect and transmute the world around them, touching upon historical precedents and twisting and turning those traditions into new visual vocabularies that evoke a vivid and freshly made present. In the end they collectively offer a prism of light and bright, of pigmented washes both transparent and opaque and simple and layered. Their ideas, processes, and articulations evidence the many possibilities of what occurs when water and color are brought together.

DEAR HANCOCK

Husband-and-wife duo Gwendolyn Mason and Earnest Merritt
formed the Dear Hancock Paper Goods company to combine
their love of painting and paper correspondence. Using their fine
art and professional design backgrounds, alongside creativity
and determination, they have created a unique brand of narrative
detail and endearing personality, inspired by a mix of nostalgia,
humor, and everyday life. Dear Hancock still believes that
the handwritten note is an important part of culture—a sincere
gesture and an art form worth preserving and reinventing.

2

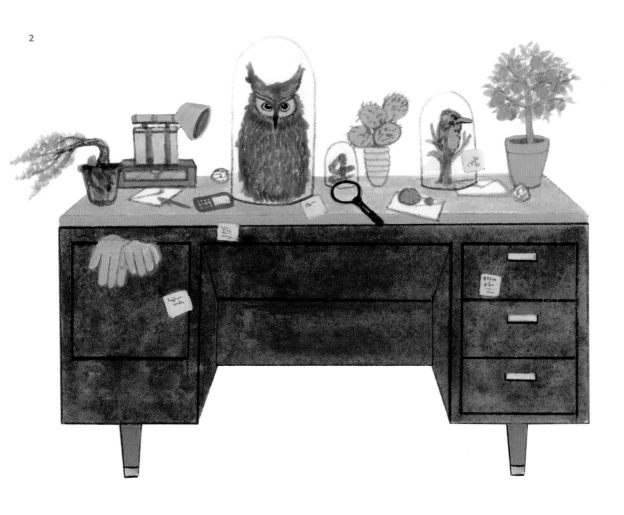

1 *Craft Desk*, 2010
Watercolor and gouache
5 × 7 in. (13 × 18 cm)

2 *Naturalist Desk*, 2011
Watercolor and gouache
5 × 7 in. (13 × 18 cm)

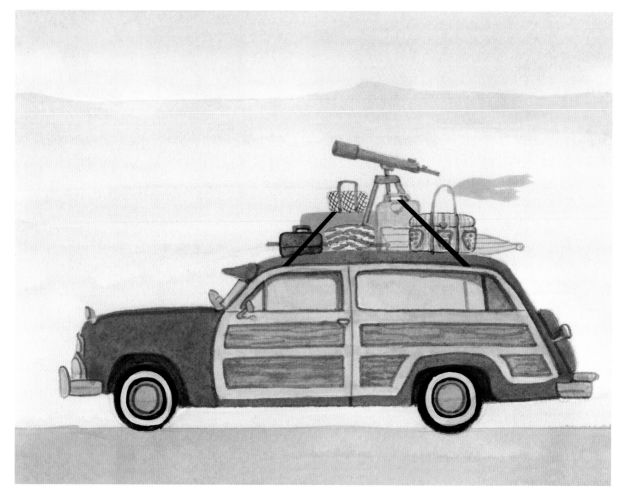

4

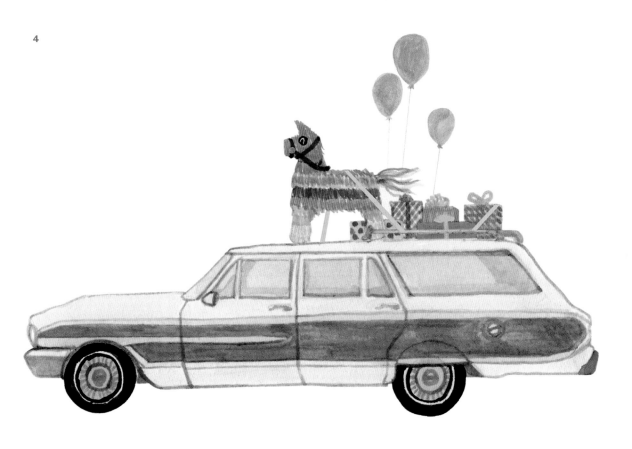

3 *Road Trip*, 2011
Watercolor and gouache
4¼ × 5½ in. (10 × 14 cm)

4 *Party on the Way*, 2011
Watercolor and gouache
4¼ × 5½ in. (10 × 14 cm)

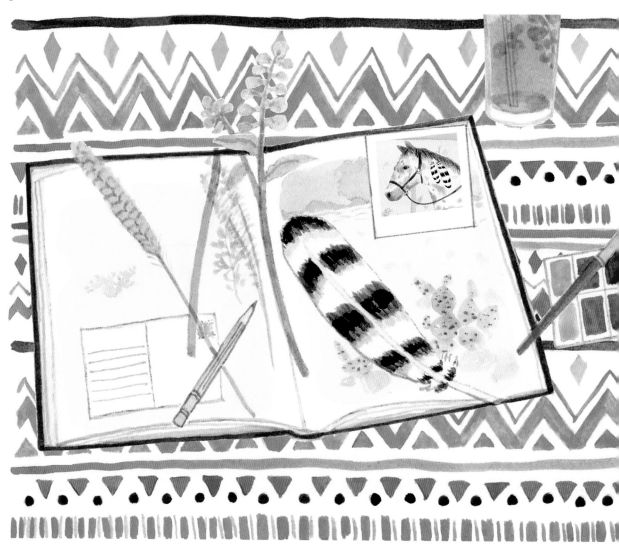

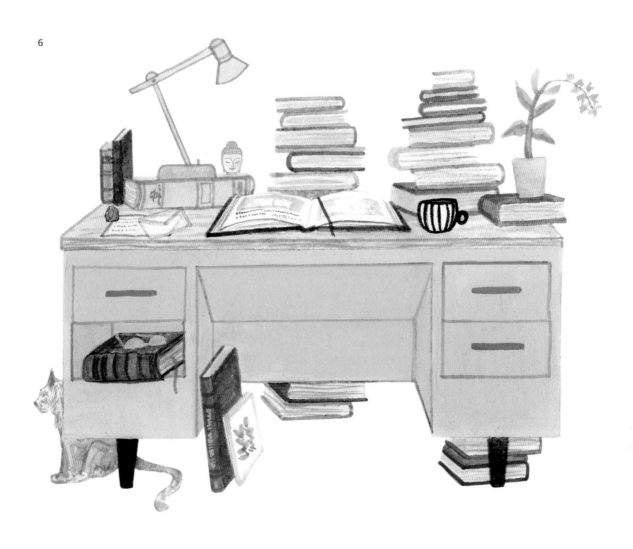

5 *Sketchbook with Feather*, 2011
Watercolor and gouache
4¼ × 5½ in. (11 × 14 cm)

6 *Book Lover's Desk*, 2011
Watercolor and gouache
5 × 7 in. (13 × 18 cm)

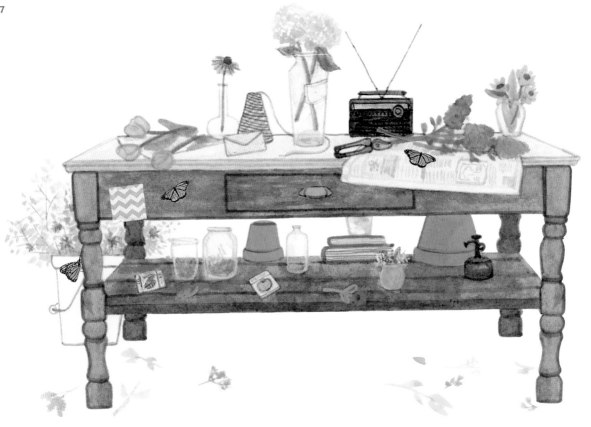

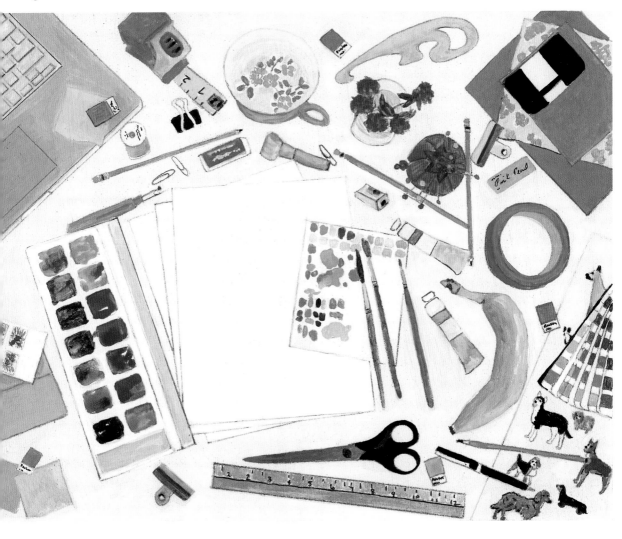

7 *Spring Desk*, 2011
Watercolor and gouache
5 × 7 in. (13 × 18 cm)

8 *Creative Workstation*, 2010
Watercolor and gouache
5 × 7 in. (13 × 18 cm)

JULIA DENOS

What Julia Denos loves most about watercolor is that it is an unforgiving medium. According to Denos, watercolor offers "a special honesty, because you can't hide any mark. Your humanity is in plain view. Even if you learn to tame it, it will always be a wild animal—it ultimately does what it wants to, no matter what substrate you choose or how many lessons you take. So you just have to accept this and play. That's what's so freeing about it! When you are using watercolor and you make a 'mistake,' there really is no going back. You can only start over or learn to coax the mistake into something beautiful. I try to always choose the latter."

1

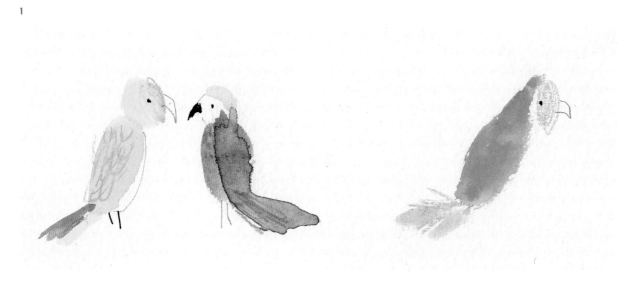

1 *Parrots*, 2011
Watercolor with pencil
3 × 6½ in. (8 × 17 cm)

2 *Tangerine*, 2011
Watercolor with crayon
6 × 4 in. (15 × 10 cm)

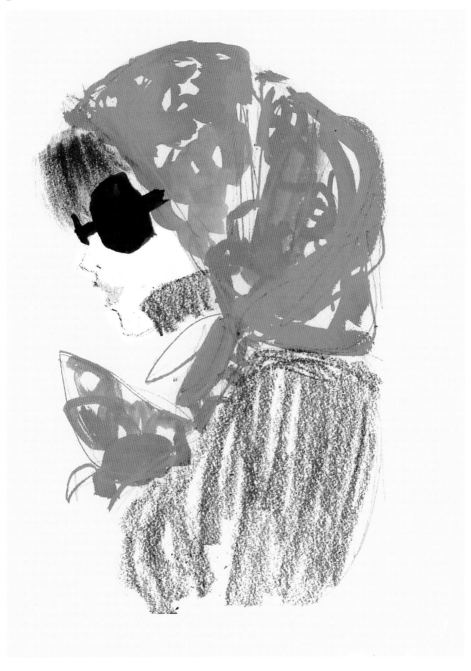

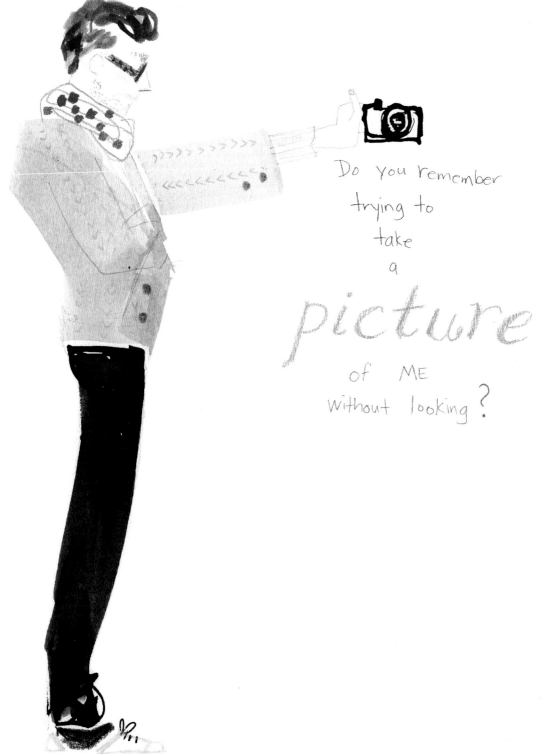

Do you remember
trying to
take
a
picture
of ME
without looking?

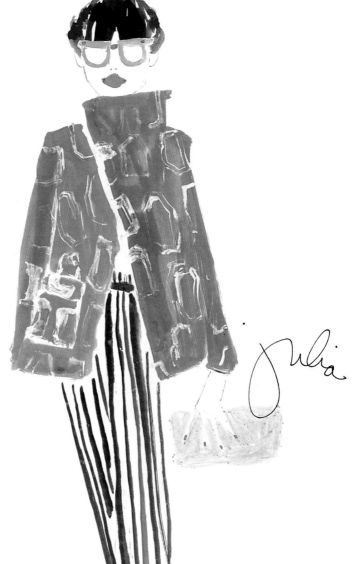

3 *Camera Man*, 2011
Watercolor with pencil and crayon
10 × 9 in. (25 × 23 cm)

4 *Ingenue Blue*, 2012
Watercolor with pencil and crayon
6 × 4 in. (15 × 10 cm)

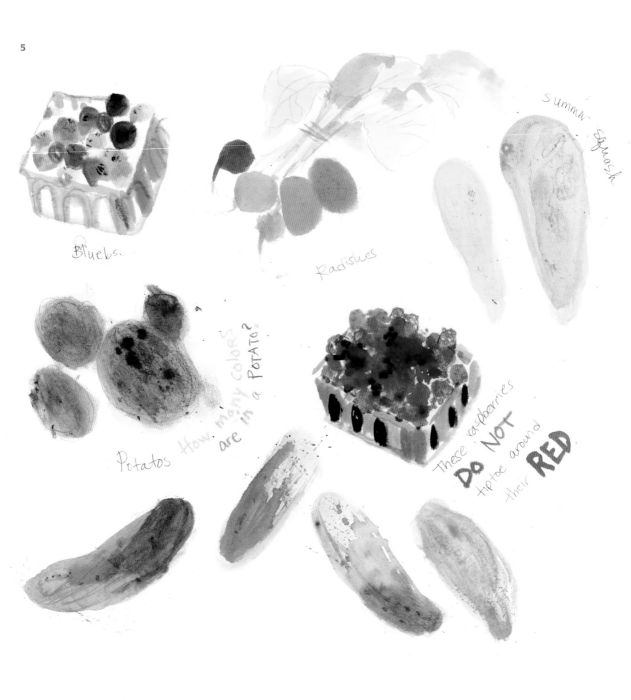

Bluebs.

Radishes

Summa Squash

Potatos How many colors are in a Potato?

These raspberries DO NOT tiptoe around their RED

the beauty of a beet.

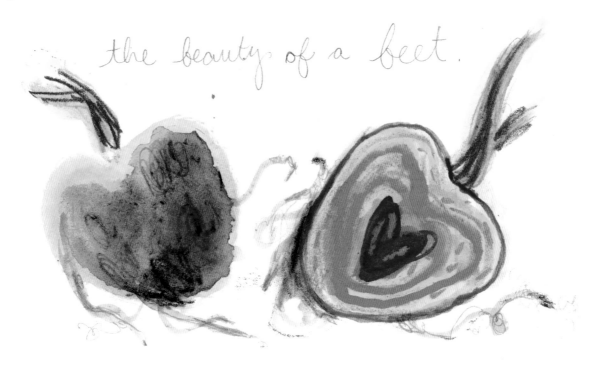

5 *Farmer's Market*, 2011
Watercolor with pencil
18 × 20 in. (46 × 51 cm)

6 *Beet*, 2011
Watercolor with pencil
7 × 11 in. (18 × 28 cm)

7 *Untitled*, 2012
Watercolor with pencil
7½ × 7½ in. (19 × 19 cm)

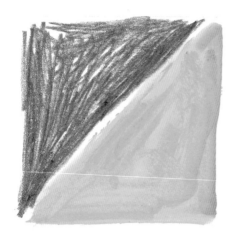

8 *Untitled*, 2012
Watercolor with crayon
10 × 4 in. (25 × 10 cm)

9 *Persimmon*, 2012
Watercolor
9 × 10 in. (23 × 25 cm)

10 *Phthalo Blue*, 2012
Watercolor
9 × 10 in. (23 × 25 cm)

11 *Lettuces and Greens*, 2011
Watercolor with pencil
14 × 10 in. (36 × 25 cm)

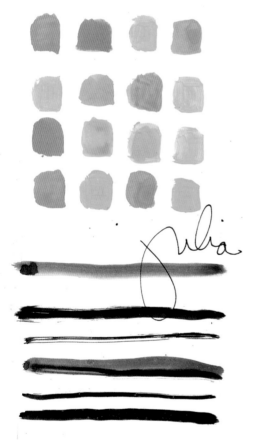

9

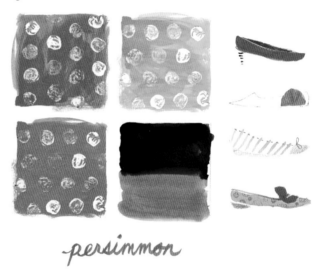

persimmon

10

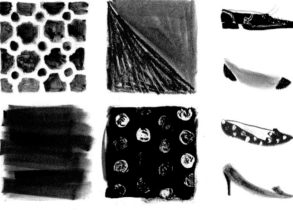

phthalo blue

greens &
lettuces
&
leaves.

basil.

lovely
chard!

arugula.

fennel
fronds.

and kale.
fuzzy frilly
kale

lettuce.

DANNY GREGORY

Of his art and his process, Danny Gregory states: "I'm a work in progress. My art is less about the end result than it is about the process—the process of understanding the world around me: its beauty, complexity, individuality, and ever-changing nature. Sometimes I use my paints to try to capture the light and color that I see as accurately as I can, layering shades, working wet. Other times, I use color sparingly, sometimes working just within the shades of one hue or working with very flat colors in a graphic way. Sometimes I pretreat my page with a random chaos of color, pooling and spilling liquid color, and then drawing on top of it, then going back to add some dimension with another layer of random splotches and splatters. Most of all, though, I love the emotional quality of watercolors; they are always in motion, drifting through layers, a bit raucous-like and unruly. I don't like super-specific painting with hard edges; I prefer the vagueness of watercolors, particularly in conjunction with an ink line from a dip pen, whereby everything is organic and a little out of control—like my life."

1 *Dog Run*, 2004
Watercolor with India ink
7 × 7 in. (18 × 18 cm)

2 *Kafka*, 2009
Watercolor with India ink
9 × 6 in. (23 × 15 cm)

3 *Mug 4*, 2004
Watercolor with India ink
8 × 5 in. (20 × 13 cm)

4 *Mug 26*, 2004
Watercolor with India ink
8 × 5 in. (20 × 13 cm)

5 *Mug 15*, 2004
Watercolor with India ink
8 × 5 in. (20 × 13 cm)

6 *Mug 10*, 2004
Watercolor with India ink
8 × 5 in. (20 × 13 cm)

7 *Hound 3*, 2008
Watercolor with India ink
9 × 6 in. (23 × 15 cm)

1

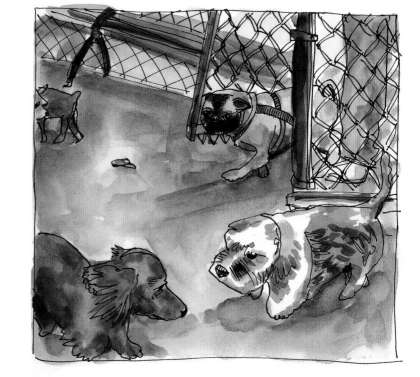

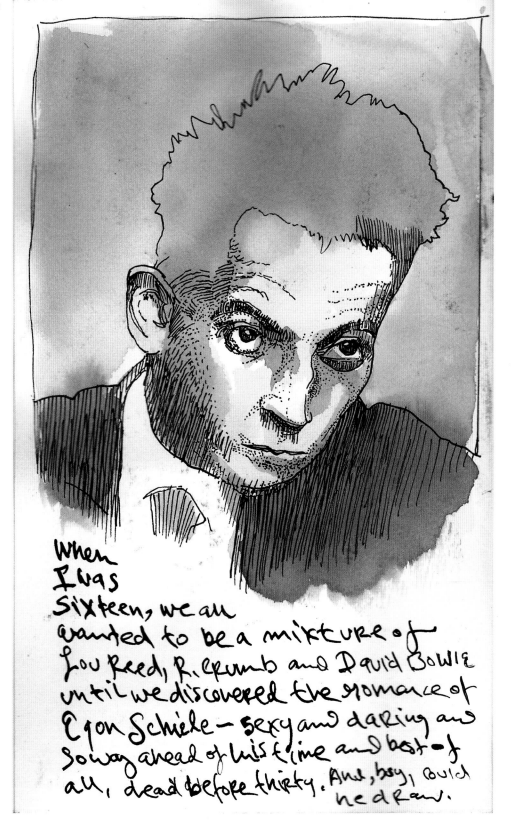

When I was sixteen, we all wanted to be a mixture of Lou Reed, R. Crumb and David Bowie until we discovered the romance of Egon Schiele — sexy and daring and so way ahead of his time and best of all, dead before thirty. And, boy, could he draw.

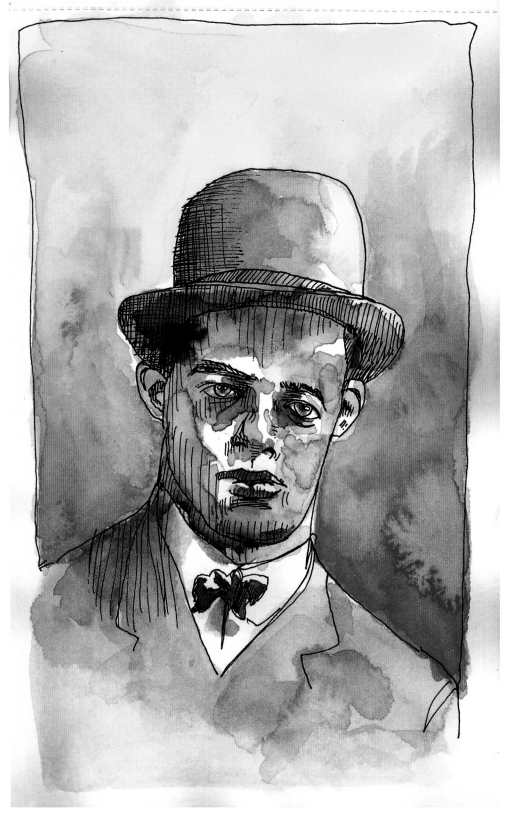

4

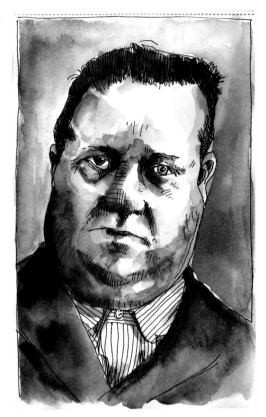

5

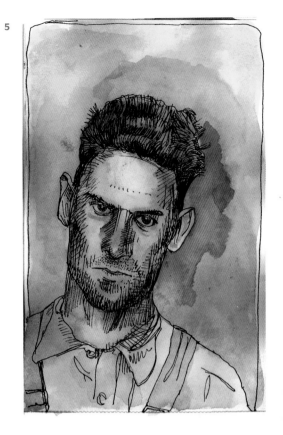

6

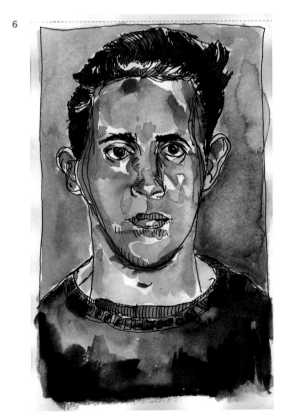

7

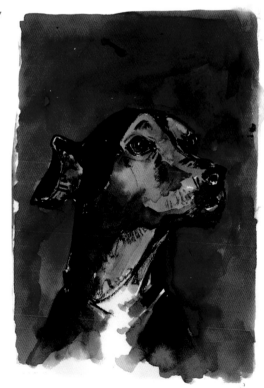

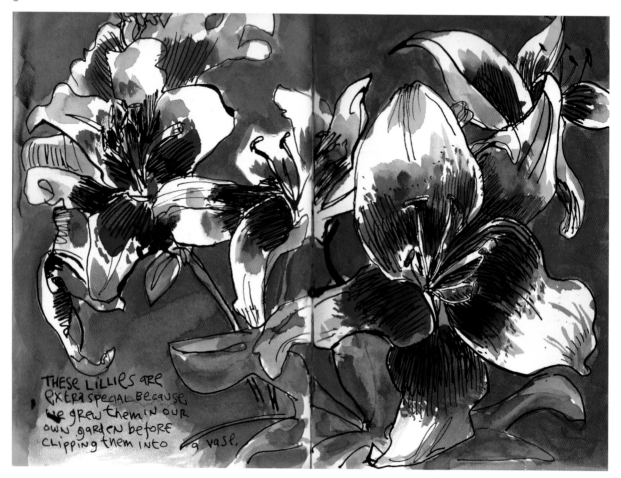

THESE LILLIES are
extra special Because
we grew them in our
own garden before
clipping them into a vase.

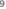
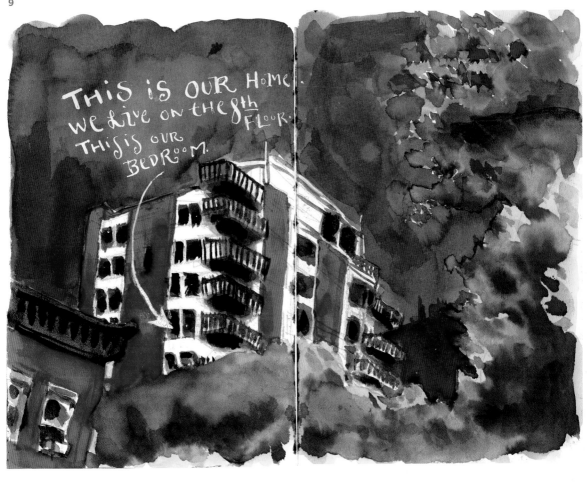

Within the artwork: THIS IS OUR HOME. WE LIVE ON THE 8th FLOOR. THIS IS OUR BEDROOM.

8 *Lilies*, 2009
Watercolor with India ink
9 × 12 in. (23 × 30 cm)

9 *Our Home*, 2011
Watercolor
9 × 12 in. (23 × 31 cm)

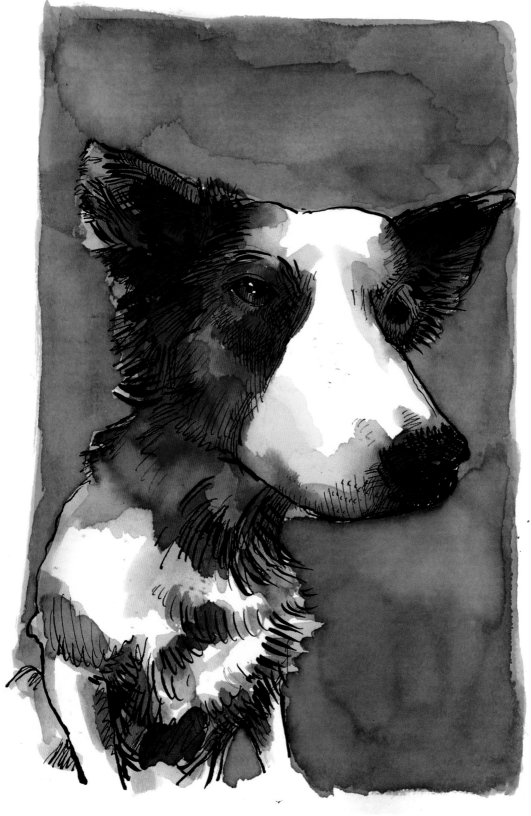

10 *Hound 2*, 2008
Watercolor with India ink
9 × 6 in. (23 × 15 cm)

11 *Church of the Immaculate*, 2005
Watercolor with ink
7 × 9½ in. (18 × 24 cm)

SAMANTHA HAHN

Samantha Hahn describes herself as "an artist consumed by the female form." She employs an expressive approach to watercolor painting, allowing color to mingle with delicate lines, and melding abstraction with observation. Hahn remarks, "I am fascinated with striking a balance between negative space and positive, between light as well as rich and luscious color."

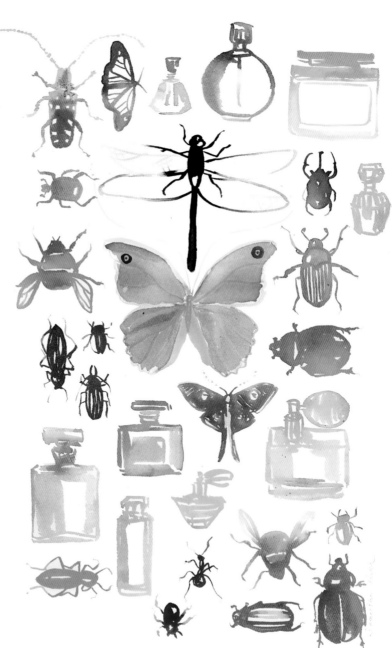

1 *Bugs and Bottles*, 2011
Watercolor
20 × 16 in. (51 × 41 cm)

2 *Helen of Troy 5*, 2011
Watercolor
14 × 11 in. (36 × 28 cm)

2

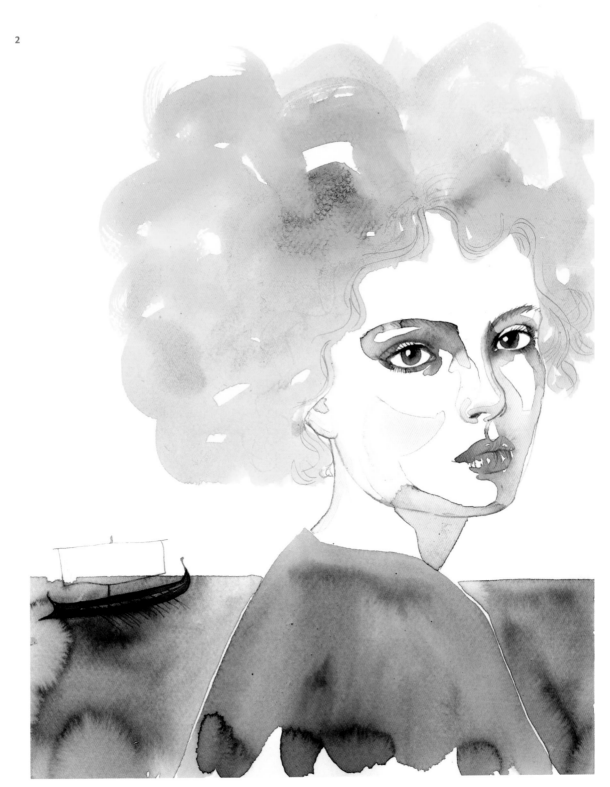

SAMANTHA HAHN

3

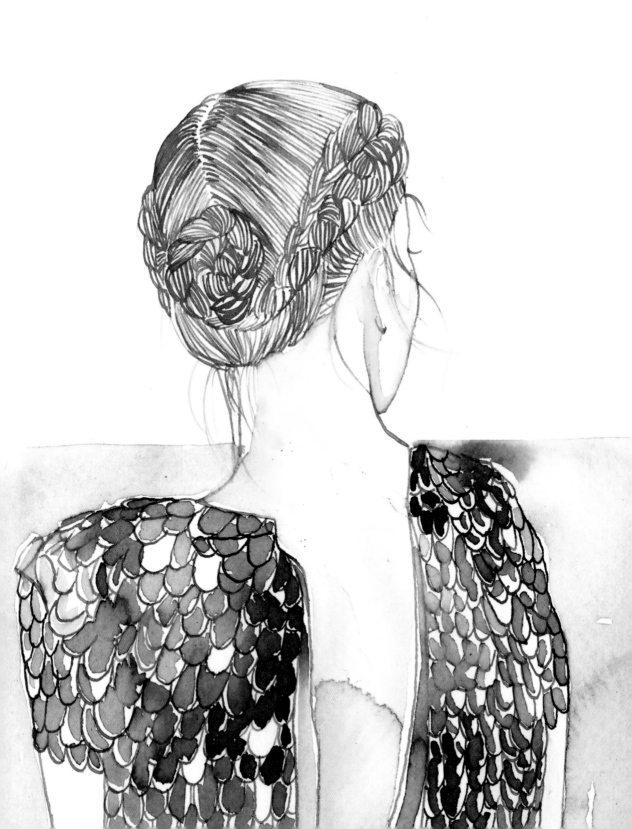

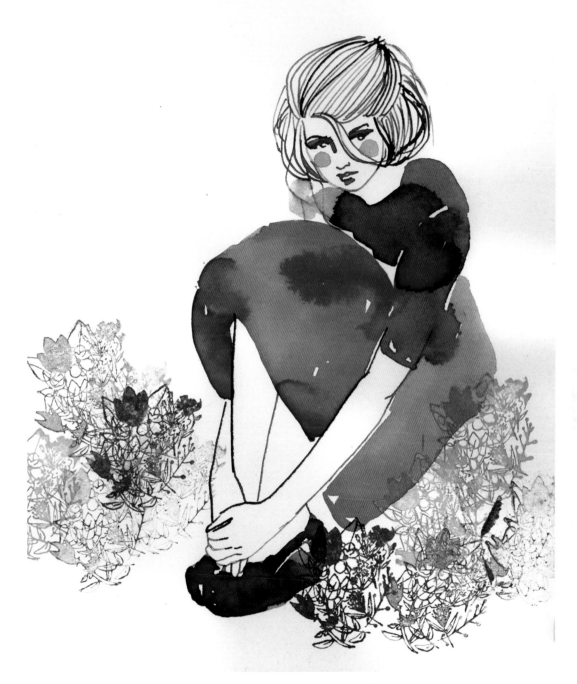

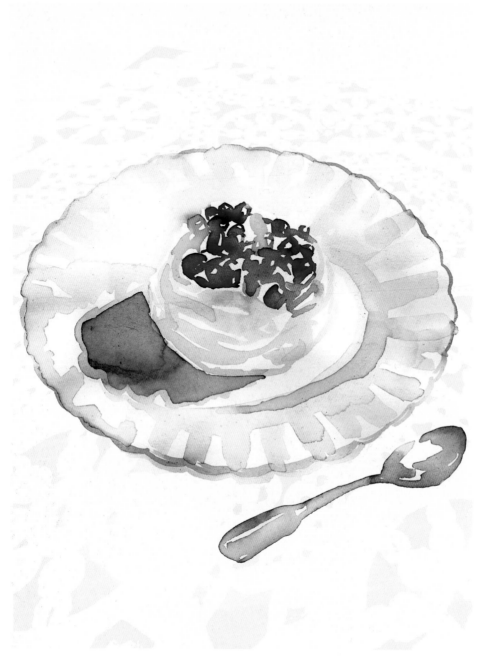

3 *Helen of Troy*, 2011
Watercolor
7 × 7 in. (18 × 18 cm)

4 *Waiting in the Garden*, 2011
Watercolor
7 × 5 in. (18 × 13 cm)

5 *Meringue with a Layer of Rose-Flavored Cream Topped with Pomegranate Jewels*, 2010
Watercolor with digital detailing
11 × 14 in. (28 × 36 cm)

6 *Phoebe Philo*, 2011
Watercolor
10 × 8 in. (25 × 20 cm)

7 *Rei Kawakubo*, 2011
Watercolor
10 × 8 in. (25 × 20 cm)

8 *Circus Master*, 2011
Watercolor
14 × 11 in. (36 × 28 cm)

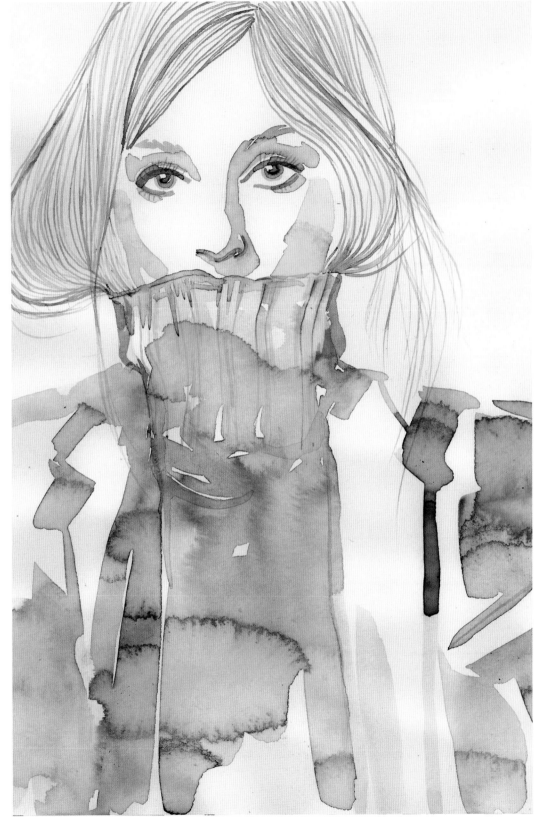

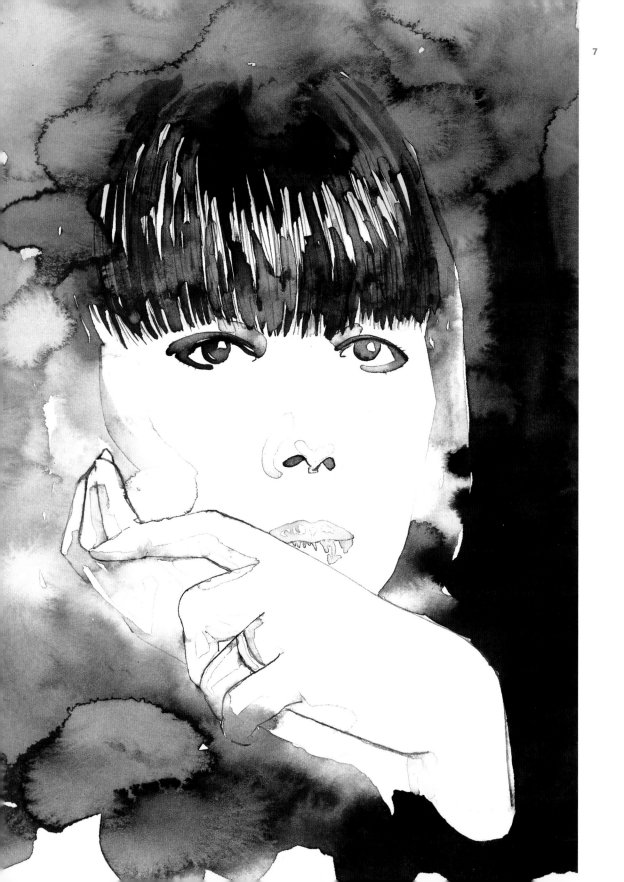

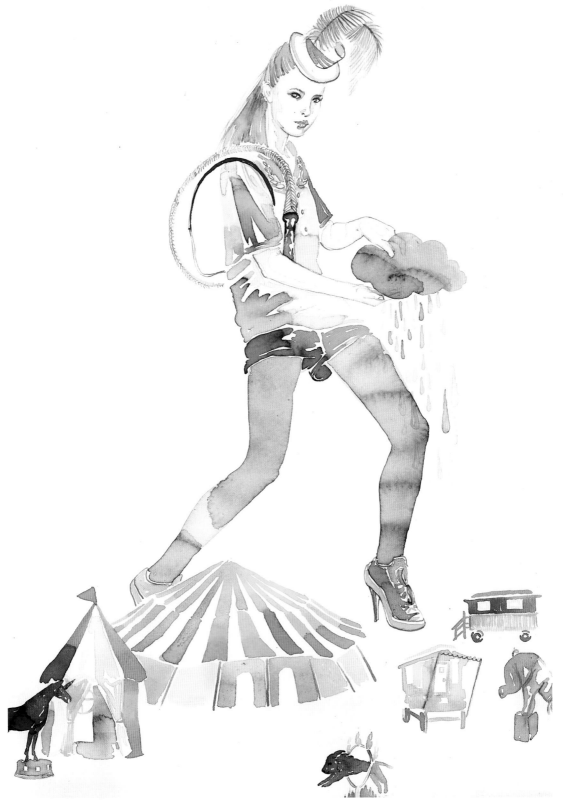

SAMANTHA HAHN

VIRGINIA JOHNSON

Virginia Johnson begins each illustration or textile design with paint and paper. She paints exclusively in watercolor because of its spontaneity and the way it allows her to work quickly and intuitively. She explains, "I love the way a wet brush soaks the paper and how vibrant the colors are. I am frequently inspired by my travels and by different cultures, crafts, and time periods. I am also particularly drawn to nature, particularly birds, trees, flowers, and animals."

1 *Sand Dollar*, 2006
Watercolor
15 × 11 in. (38 × 28 cm)

2 *Bijoux*, 2011
Watercolor
11 × 8½ in. (28 × 22 cm)

3 *Waterfall*, 2006
Watercolor
7 × 5 in. (18 × 13 cm)

4 *Potted Fern*, 2012
Watercolor
12 × 6 in. (30 × 15 cm)

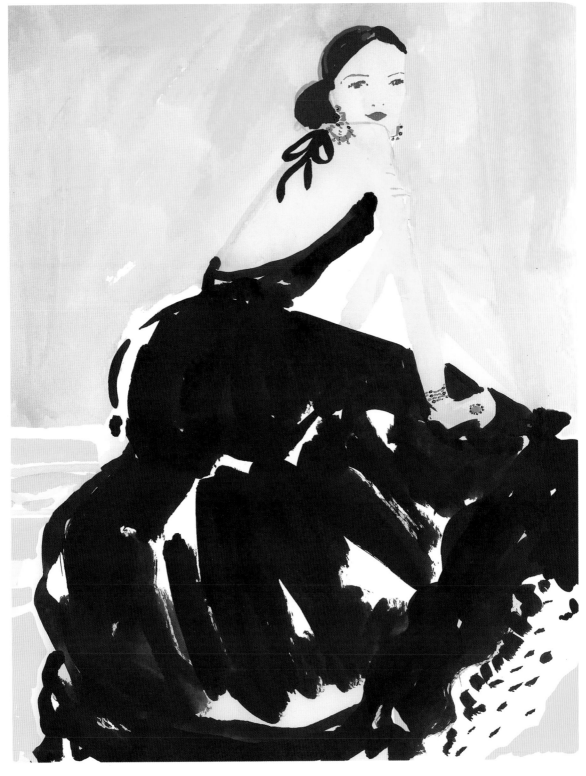

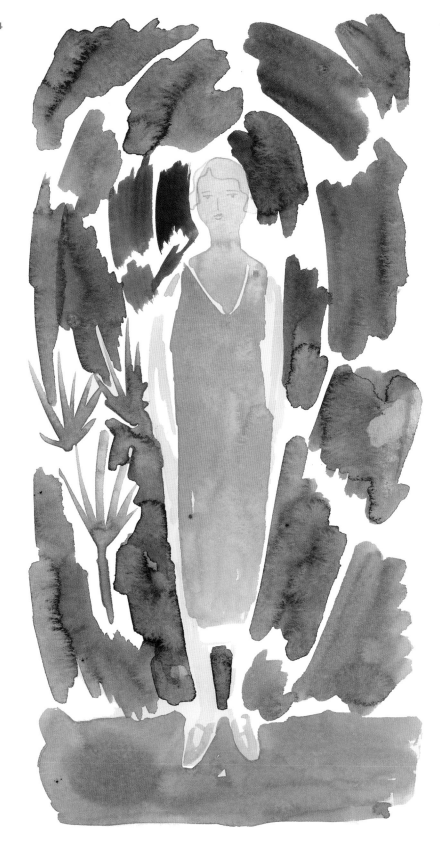

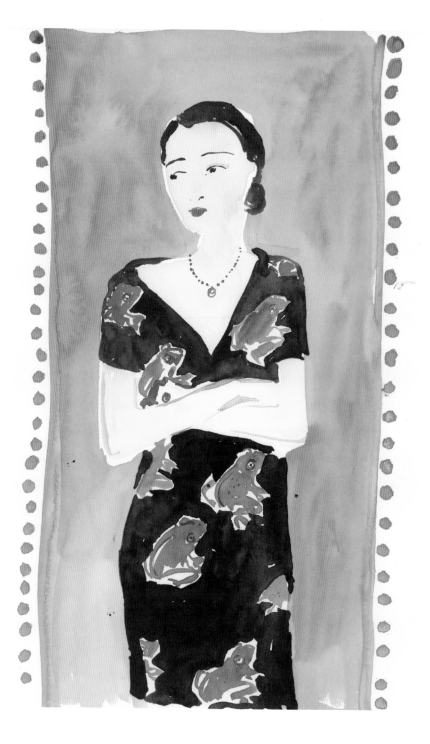

5 *Frog Dress*, 2004
Watercolor
11 × 7½ in. (28 × 19 cm)

6 *Lantern*, 2010
Watercolor
10 × 9 in. (25 × 23 cm)

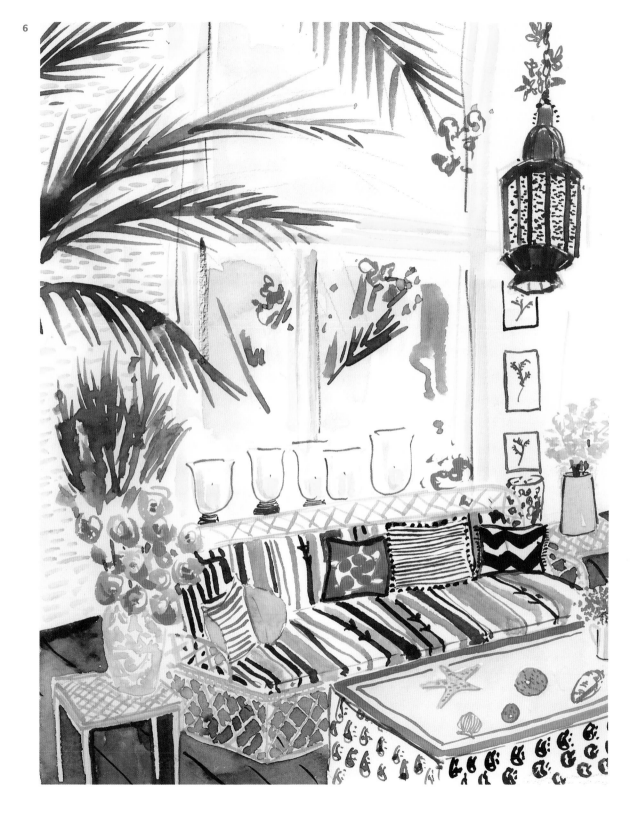

ANNA EMILIA LAITINEN

Weather, seasons, and landscapes are what inspire Anna Emilia Laitinen, the daughter of strawberry farmers. "It feels natural to observe what happens around me in nature," the artist says, "and how things are connected to each other—how they make each other possible, like the way a shore surrounds a lake to form it, and the way that rain and sunshine enable seeds to grow. Patterns and colors come with the weather outside, and they are reflected in my cup of green tea."

1 *Spring Bracelet*, 2010
Watercolor
20 × 20 in. (50 × 50 cm)

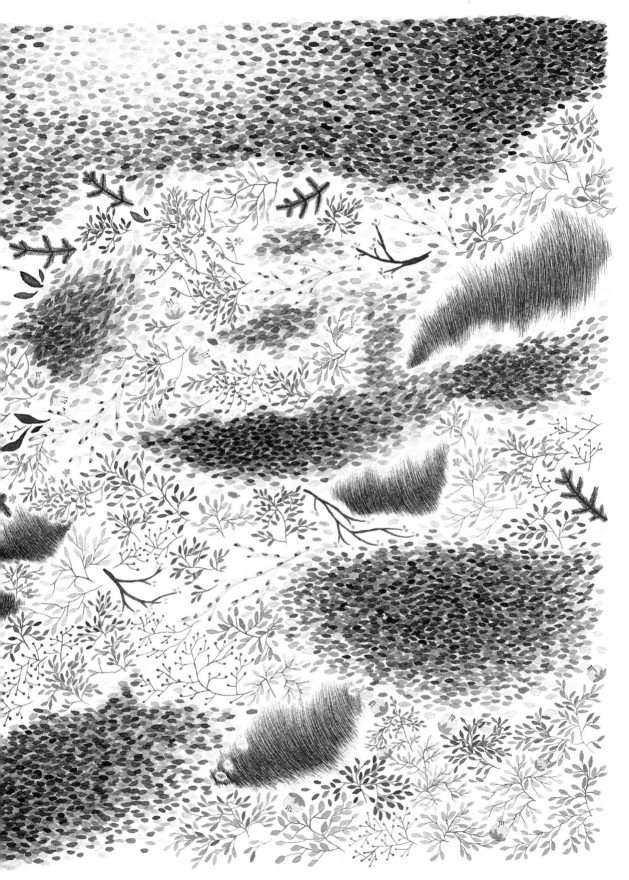

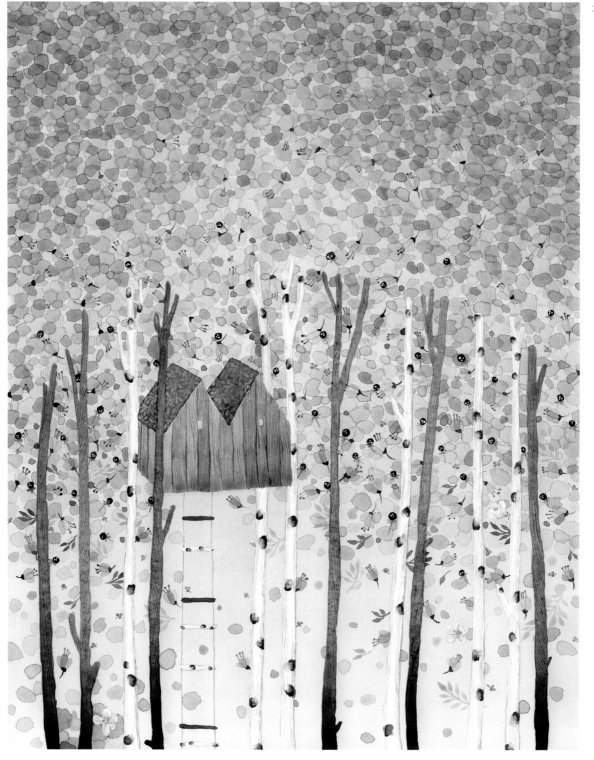

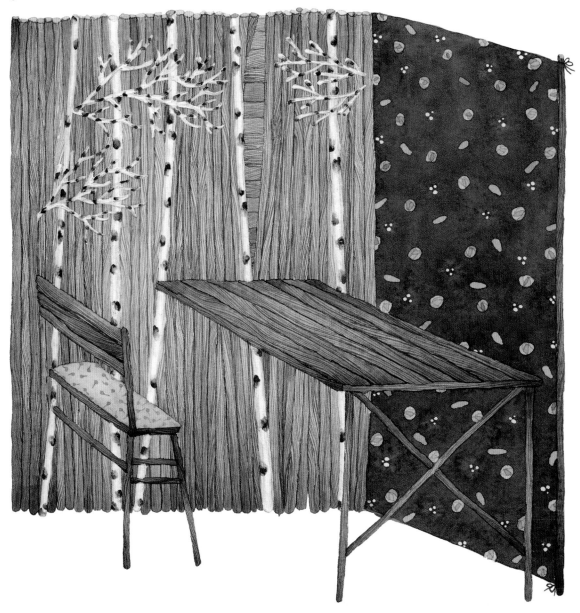

2 *Tree House*, 2011
Watercolor
15 × 12 in. (38 × 30 cm)

3 *Forest Studio*, 2010
Watercolor
12 × 12 in. (30 × 30 cm)

WATERCOLOR

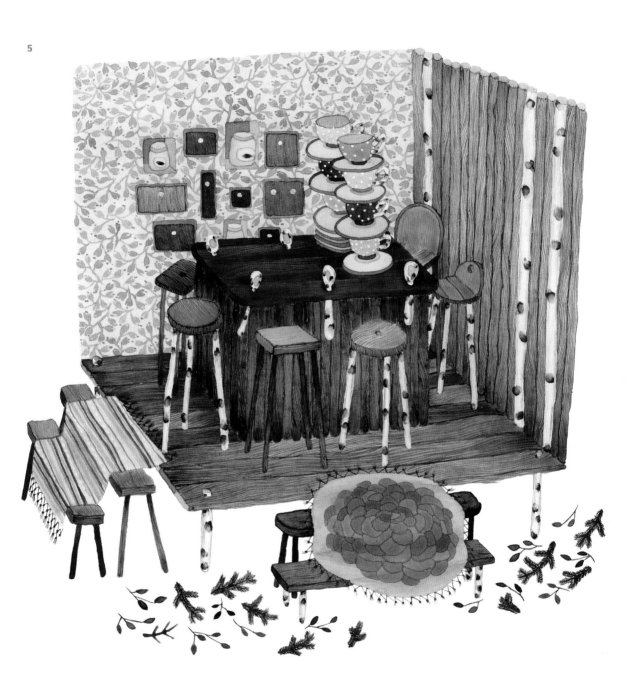

4 *Birch Village*, 2010
Watercolor
9½ × 12 in. (30 × 24 cm)

5 *Forest Tearoom*, 2010
Watercolor
14 × 13 in. (36 × 33 cm)

6 *In Meadow*, 2011
Watercolor
10½ × 12 in. (27 × 30 cm)

7 *Meadow Playing*, 2011
Watercolor
14 × 13 in. (36 × 33 cm)

DAIRE LYNCH

With each of his watercolor works, Daire Lynch strives to capture the essence of a person—his or her personality, his or her energy. He does this with a pared-down approach to color, using primarily French ultramarine for his compositions. According to the artist, the human essence is found "in the glint in the eyes, the corners of the mouths, the way somebody tilts his or her head. All these tiny nuances speak volumes of the subject, which I can only hope I convey in my art. For me, the core of the person is visible in the pupil; as such, though not always, I tend to make this the focal point of my works."

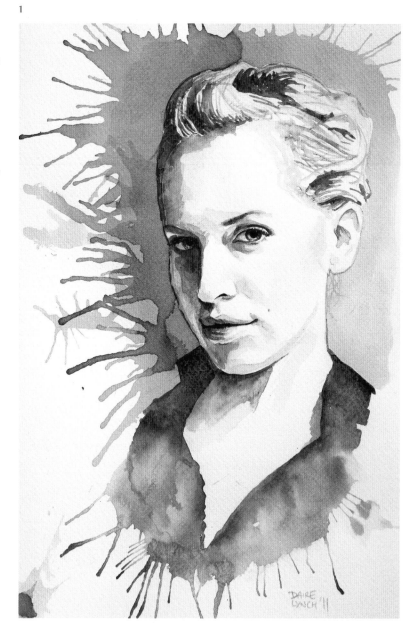

1

1 *Anna*, 2008
Watercolor with red wine
10 × 7 in. (25 × 18 cm)

2 *Mr. Black*, 2009
Watercolor
14 × 10 in. (36 × 25 cm)

3 *Pocha*, 2008
Watercolor
14 × 10 in. (36 × 25 cm)

4 *Nancy*, 2011
Watercolor
11 × 9 in. (28 × 23 cm)

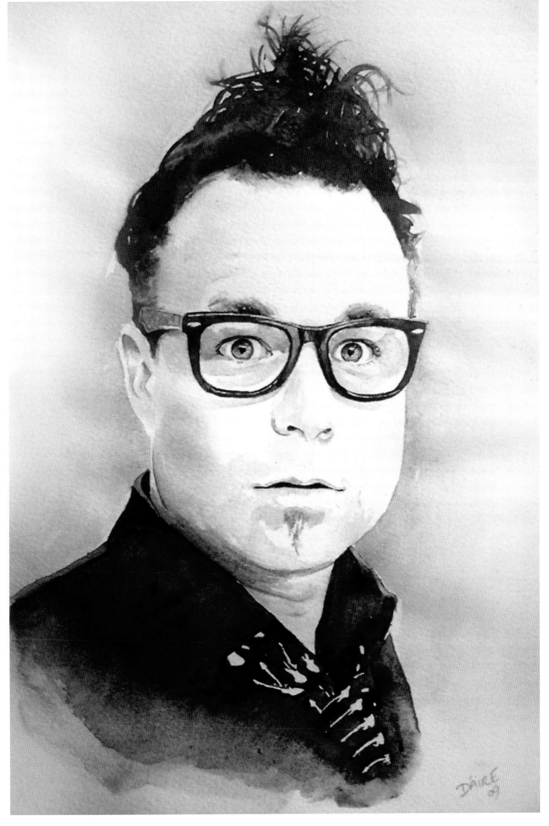

DAIRE LYNCH

4

DAIRE LYNCH

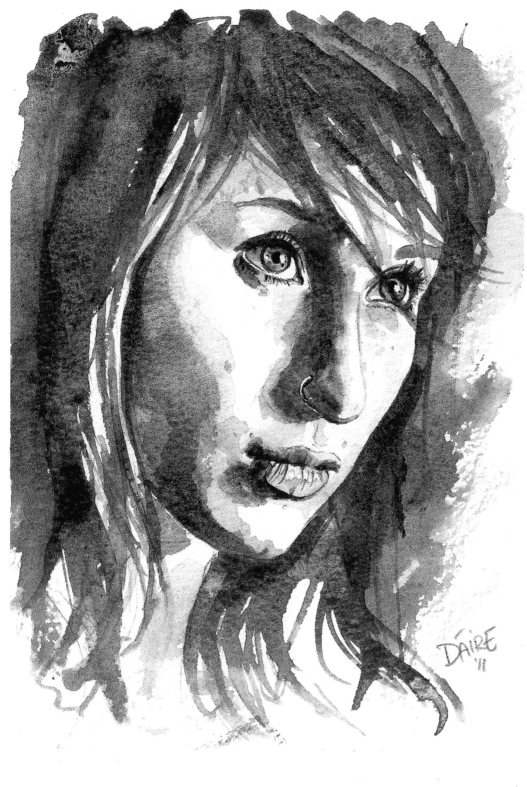

6

7

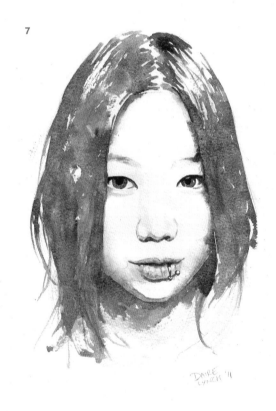

5 *Madison*, 2011
Watercolor
10 × 7 in. (25 × 18 cm)

6 *Blaithin'*, 2011
Watercolor
14 × 10 in. (36 × 25 cm)

7 *Yolanda*, 2011
Watercolor
14 × 10 in. (36 × 25 cm)

FABRICE MOIREAU

Beloved for his depictions of Paris rooftops and other city and country scenes in France, Italy, and elsewhere, Fabrice Moireau is a painter who began to create watercolors on the pages of spiral notebooks during a trip in Czechoslovakia in 1987. He has since traveled to the Caribbean, China, Great Britain, Hungary, India, Japan, Morocco, the Netherlands, Portugal, Turkey, and the United States, among other places, capturing these locales in watercolor—always from life, never from photographs—often through his favorite subject of architecture. Watercolor has served Moireau well during his travels, as it is quick in its rendering and drying, and it is also easy to carry. Despite these advantages, the artist still believes it to be a difficult medium to master, each subject requiring concentration and a struggle with light, time, and, occasionally, the weather. Moireau has painted more than four thousand watercolors.

1

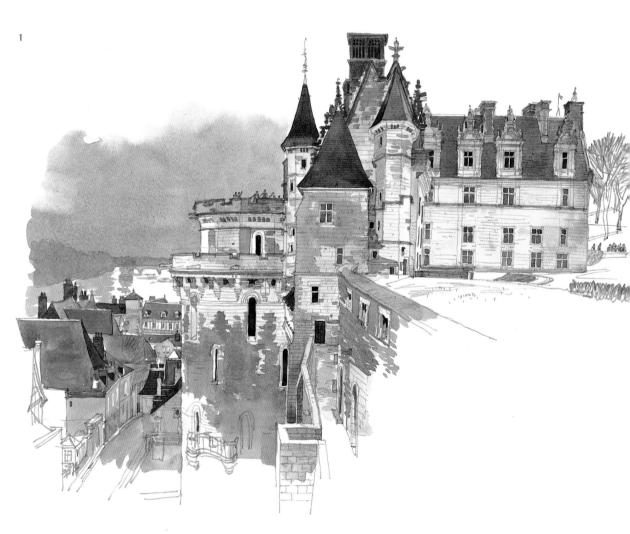

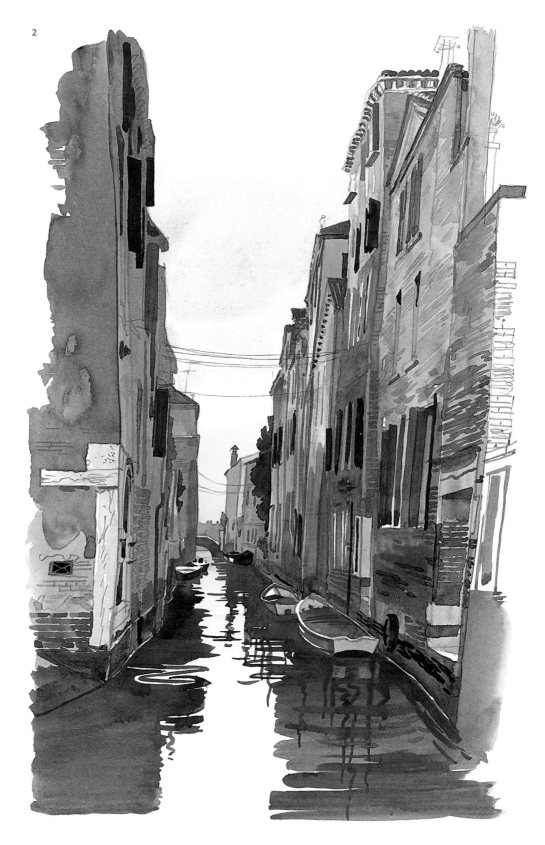

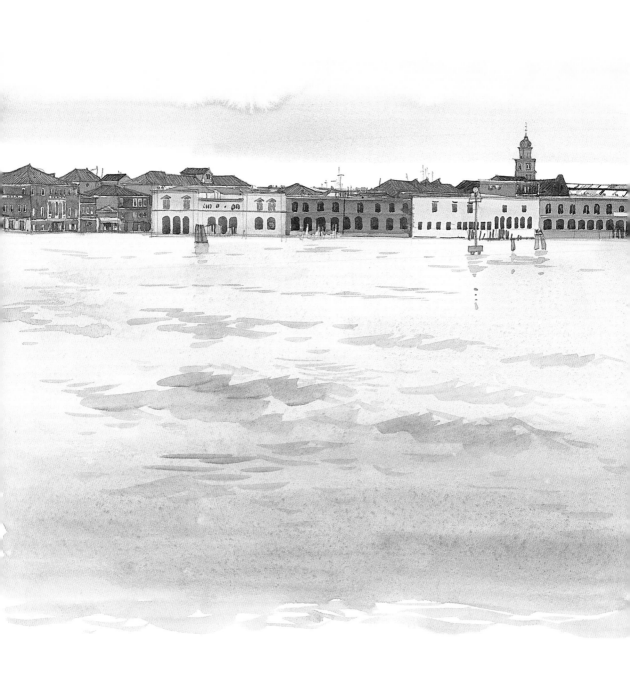

1 *Loire Valley, Château d'Amboise*, 2003
Watercolor
16½ × 19 in. (42 × 48 cm)

2 *Venice, Rio delle Torreselle*, 2004
Watercolor
13 × 10 in. (34 × 26 cm)

3 *Venice, Murano*, 2004
Watercolor
17 × 19 in. (44 × 48 cm)

4 *Rome, Vatican*, 2011
Watercolor
12½ × 19 in. (32 × 48 cm)

5 *Paris, Bois de Vincennes*, 2006
Watercolor
12½ × 19 in. (32 × 48 cm)

4

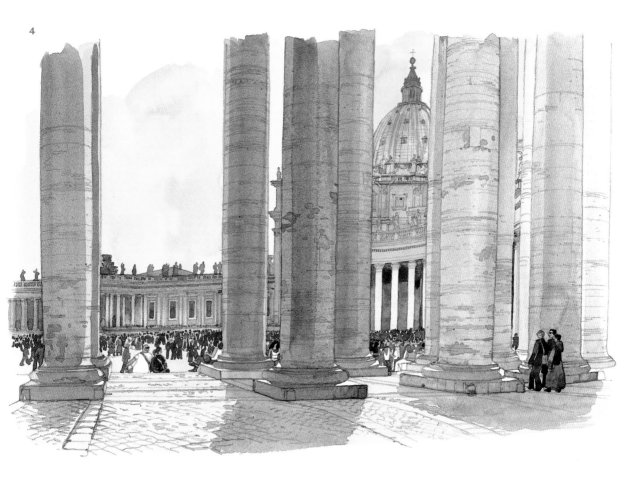

5

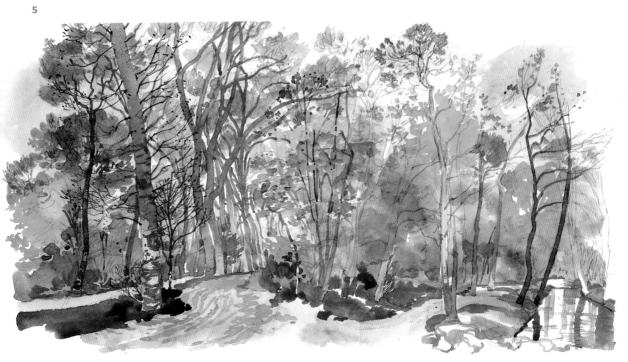

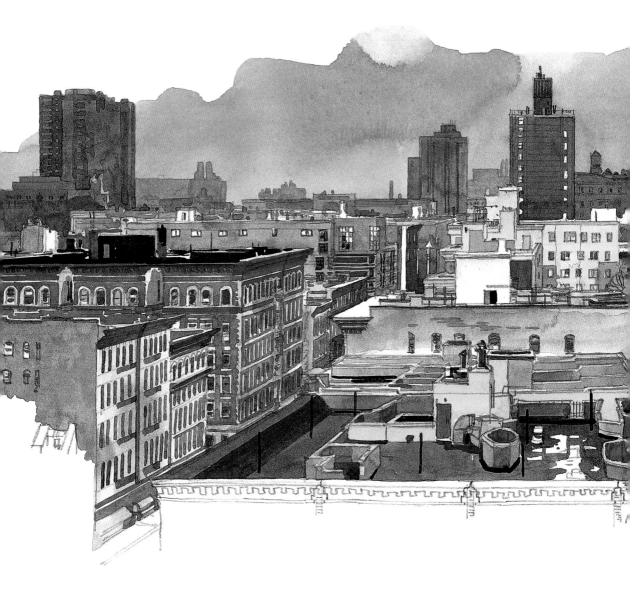

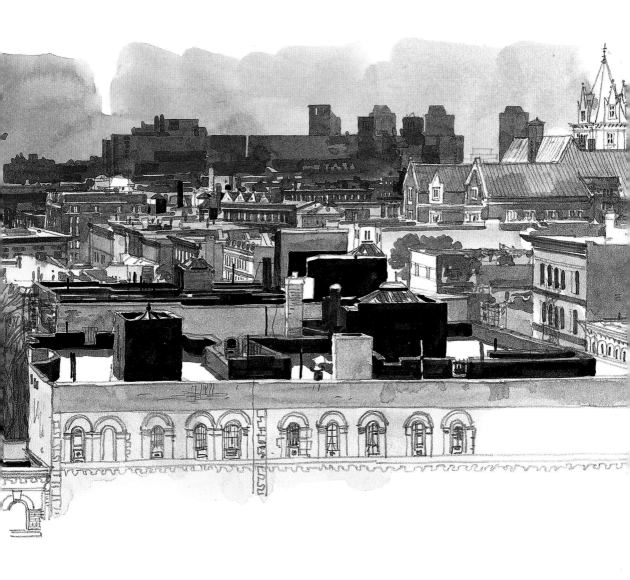

6 *New York, Harlem*, 2005
Watercolor
12½ × 19 in. (32 × 48 cm)

7 *Paris, Vue du centre Georges-Pompidou*, 2010
Watercolor
12½ × 19 in. (32 × 48 cm)

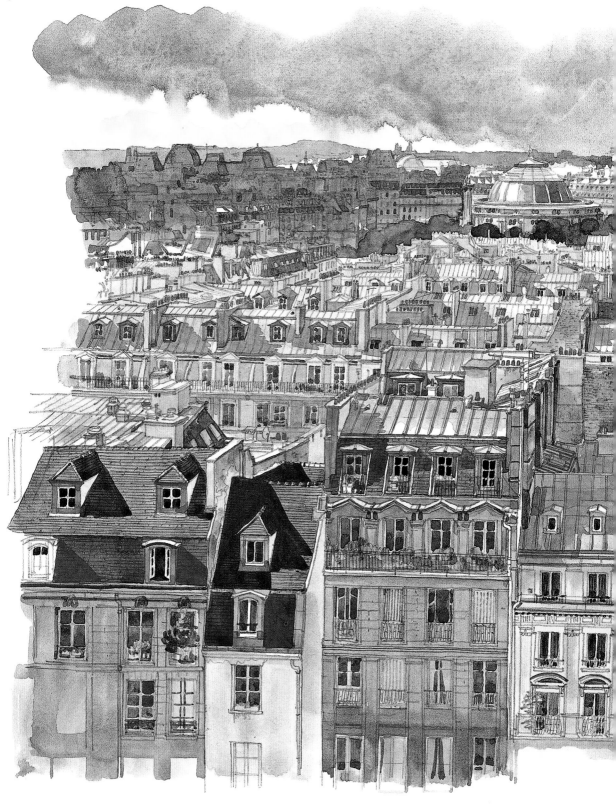

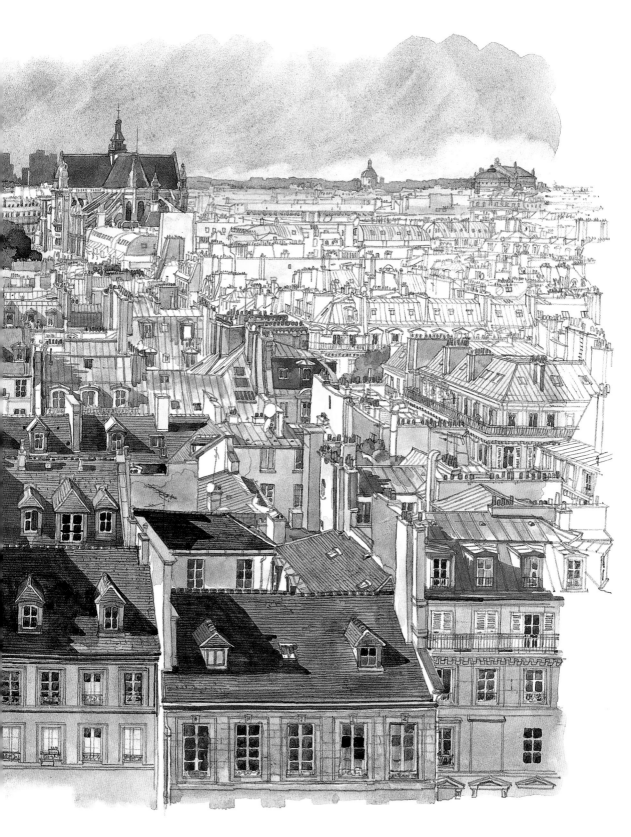

JANE MOUNT

Jane Mount is well-known for her *Ideal Bookshelf* series, in which she paints portraits of people through the spines of their favorite books. "I'm not sure you can tell a book by its cover," she confesses, "but you can learn a lot about a person from the covers of their books. I love that a book is something created very personally and then mass-produced in order to affect many other people very personally. I paint books to turn them back into something intimate."

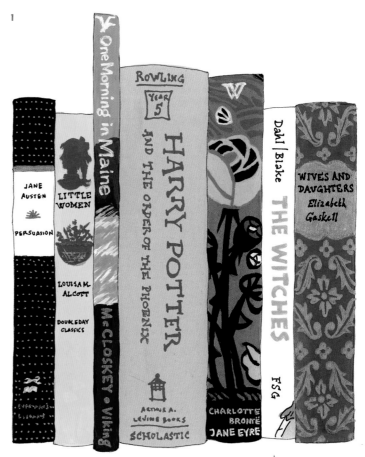

1 *Ideal Bookshelf 261: CAF*, 2011
Gouache with ink
8 × 10 in. (20 × 25 cm)

2

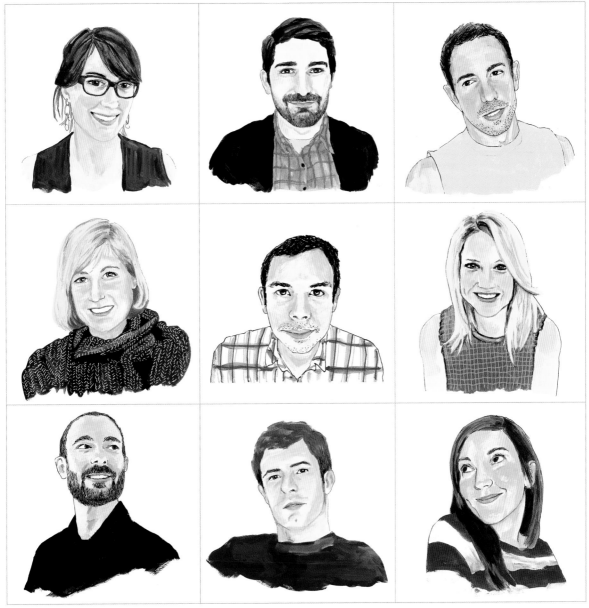

2 *Portraits of the 20×200 Staff: Carrie, Greg, Jeffrey, Tamara, David, Sarah, Brian, Edward, Stephanie*, 2010–2011
Gouache with ink
Each 6 × 6 in. (15 × 15 cm)

3 *132 Birds Leaving the AMNH (Response to Jason Polan)*, 2008
Gouache with ink
17 × 24 in. (43 × 61 cm)

81

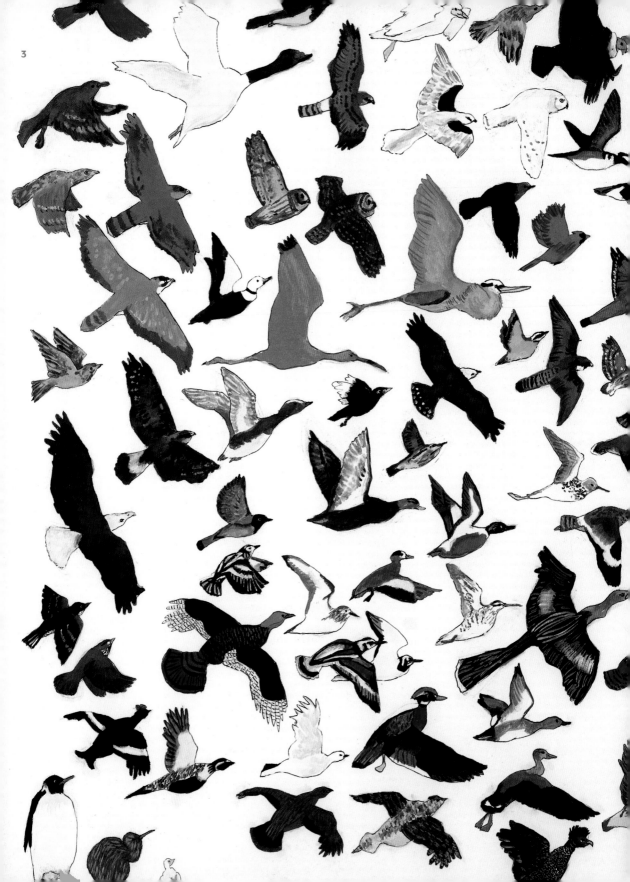

4

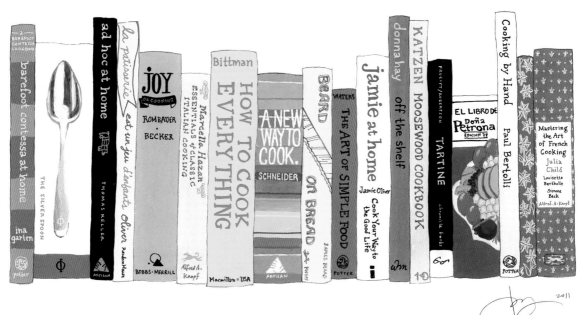

5

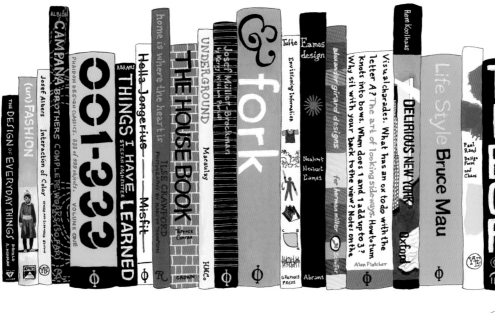

WATERCOLOR

4 Ideal Bookshelf 102: Cooking, 2010
Gouache with ink
12 × 16 in. (30 × 41 cm)

5 Ideal Bookshelf 275: Design, 2011
Gouache with ink
11 × 14 in. (28 × 36 cm)

6 Pile of AMNH Rocks (Response to Jason Polan), 2011
Gouache with ink
14 × 20 in. (28 × 51 cm)

6

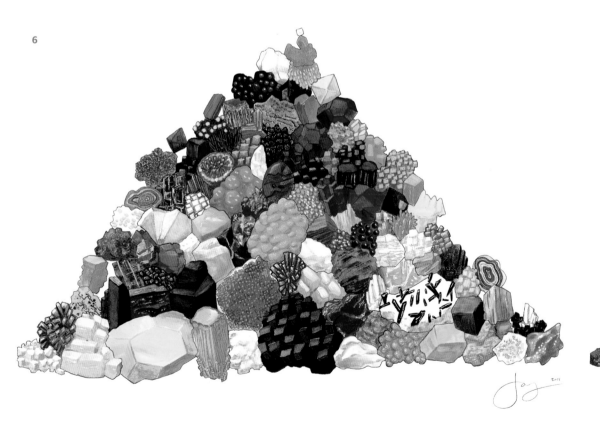

WATERCOLOR

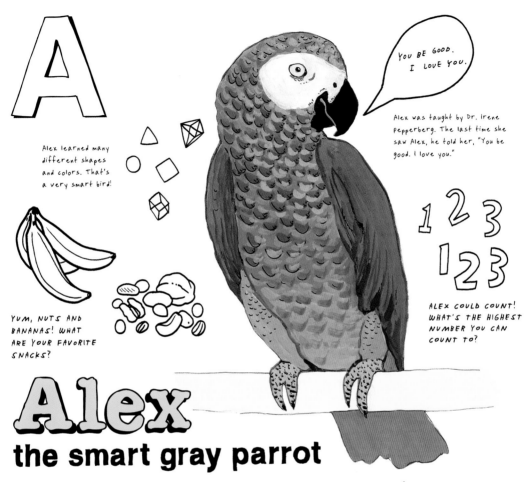

A

Alex learned many different shapes and colors. That's a very smart bird!

YUM, NUTS AND BANANAS! WHAT ARE YOUR FAVORITE SNACKS?

YOU BE GOOD. I LOVE YOU.

Alex was taught by Dr. Irene Pepperberg. The last time she saw Alex, he told her, "You be good. I love you."

ALEX COULD COUNT! WHAT'S THE HIGHEST NUMBER YOU CAN COUNT TO?

Alex
the smart gray parrot

ALEX THE GRAY PARROT WAS AN AMAZING TALKING BIRD! HE COULD SAY AND UNDERSTAND MANY, MANY THINGS INCLUDING "WANT A NUT!", "BANANA" AND "I'M SORRY". HE COULD ALSO COUNT, NAME COLORS AND SHAPES, AND SAY IF HE WAS HAPPY OR SAD.

7 *Ideal Bookshelf 254: SAS*, 2011
Gouache with ink
9 × 12 in. (23 × 30 cm)

8 *Ideal Bookshelf 353: English Lit*, 2011
Gouache with ink
11 × 16 in. (28 × 41 cm)

9 *26 Animals: Alex the Smart Gray Parrot*, 2009
Gouache with ink
8½ × 8½ in. (22 × 22 cm)

AMY PARK

Important elements of Amy Park's artistic practice include "watercolor, architecture, good paper, straight lines, looking at abstract paintings, color theory, composition, buildings I see every day and ones I have never seen, yoga, walking through new cities, my camera, museums." With architecture and abstraction as her subject matter, Park creates paintings in watercolor. "This choice is out of my love for the medium," she says. "I like how unpredictable it can be if I let it, but I also love how I am able to paint a straight line. Every painting requires a meditative state, whereby I just paint the lines, building a building on the paper."

1 *Aalto's Hidden Entrance*, 2007–2008
Watercolor
48 × 48 in. (122 × 122 cm)

2 *Mirrored Wall*, 2008
Watercolor
45 × 36 in. (114 × 91 cm)

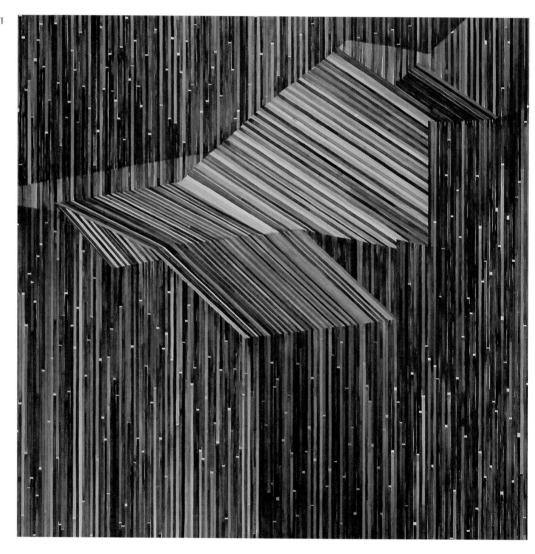

1

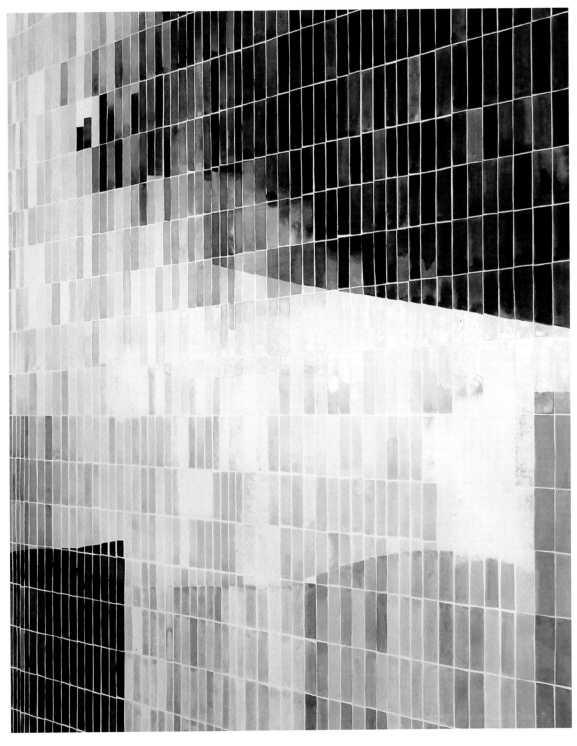

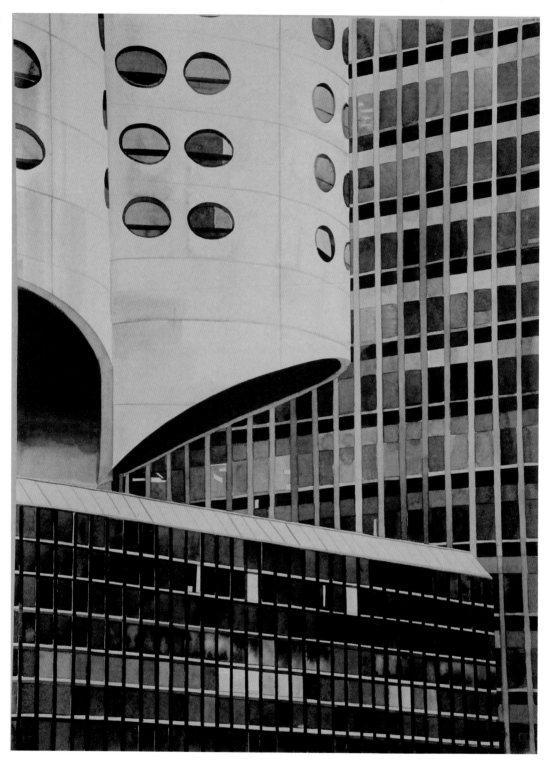

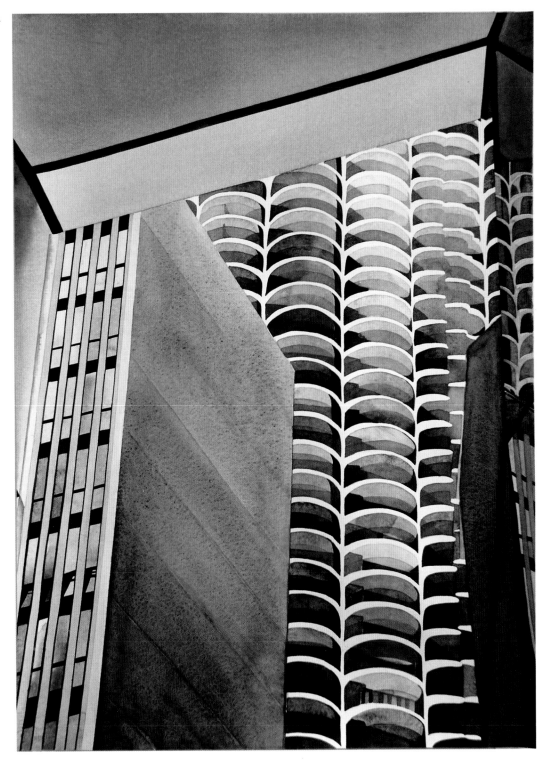

5

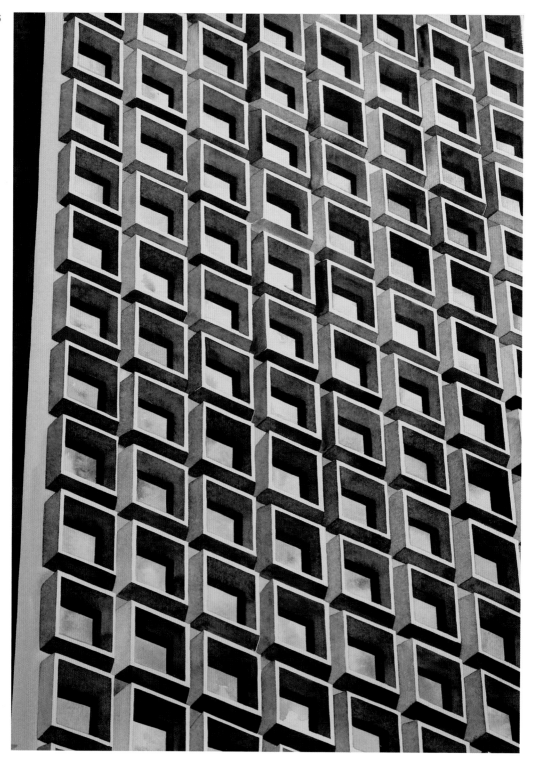

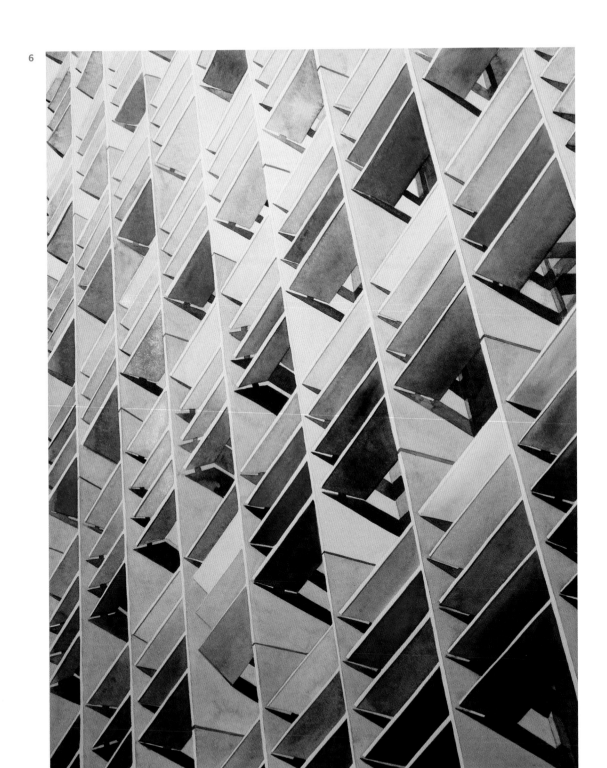

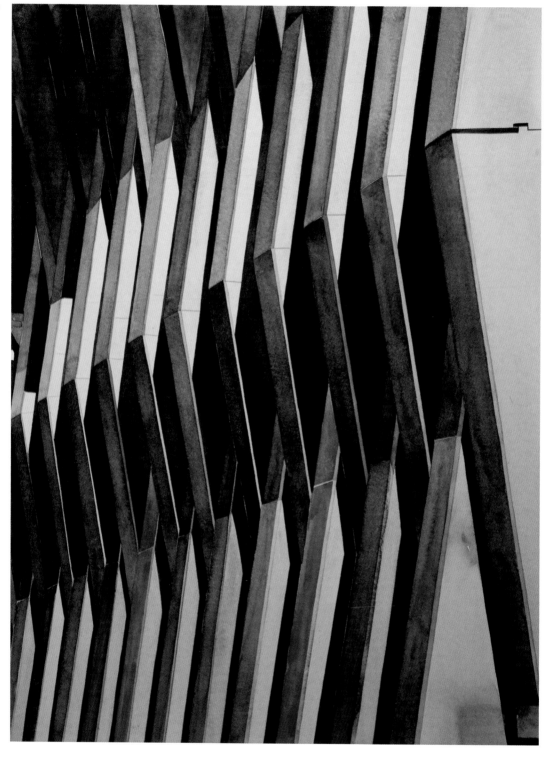

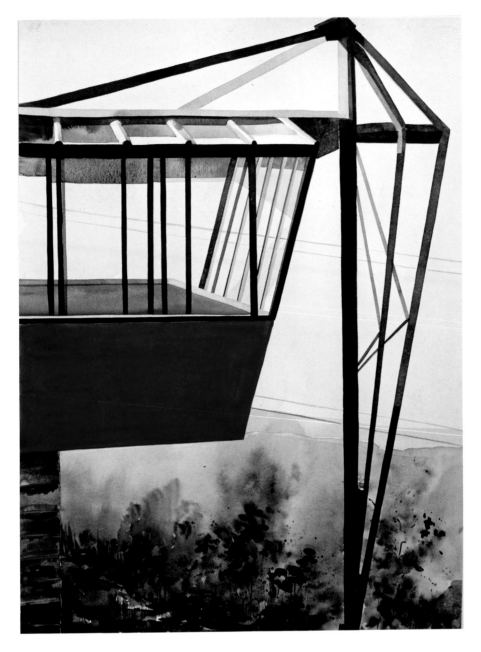

3 *Three Chicago Buildings*, 2011
Watercolor
30×22 in. (76×56 cm)

4 *Goldberg in Chicago*, 2010
Watercolor
30×22 in. (76×56 cm)

5 *Blue-Violet Post Office*, 2010
Watercolor
30×22 in. (76×56 cm)

6 *Niemeyer Façade*, 2010
Watercolor
30×22 in. (76×56 cm)

7 *Argos Building for Experimental Concrete*, 2010
Watercolor
60×48 in. (152×122 cm)

8 *Balance*, 2011
Watercolor
30×22 in. (76×56 cm)

CATE PARR

In her artwork, Cate Parr focuses on color, texture, body gestures, and movement. Her love of painting coalesces with her interest in fashion, in visual narratives that are exciting and ever changing. Her fluid paintings are guided by experimentation and spontaneity. In watercolor, states the artist, "it's the mistakes and the unexpected that make this medium so alluring."

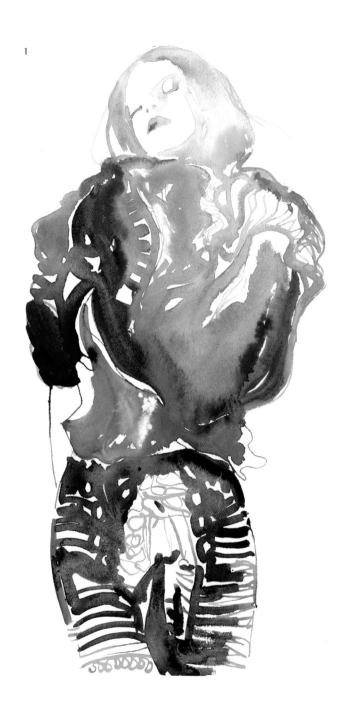

1

1 *Blumen*, 2011
Watercolor with ink
15 × 11 in. (38 × 28 cm)

2 *Eva*, 2011
Watercolor
15 × 11 in. (38 × 28 cm)

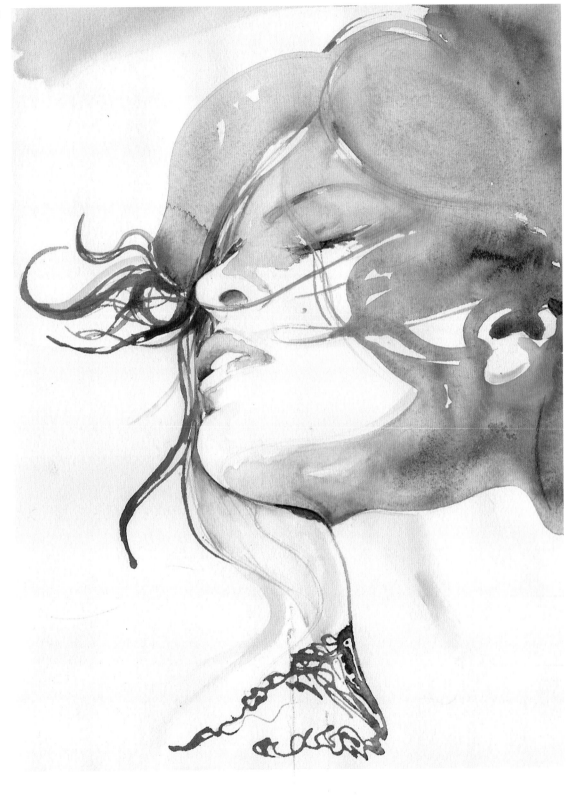

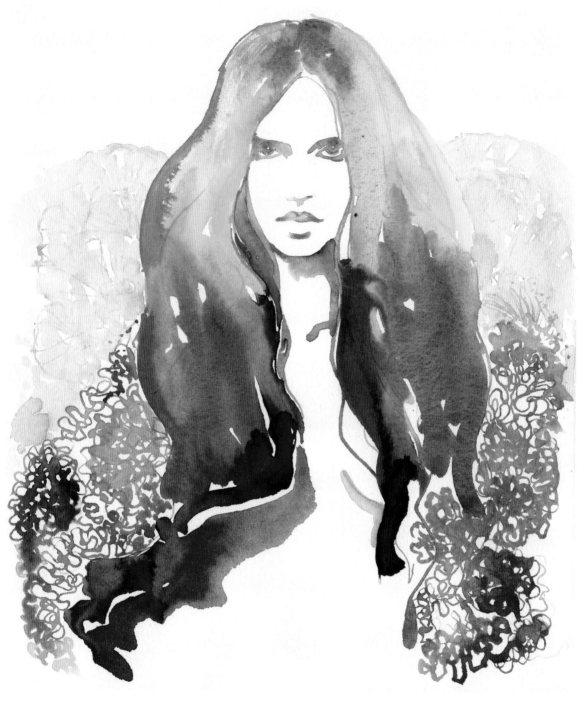

3 *Autumn*, 2010
Watercolor with ink
15 × 11 in. (38 × 28 cm)

4 *Modelink*, 2010
Watercolor
10 × 8 in. (25 × 20 cm)

4

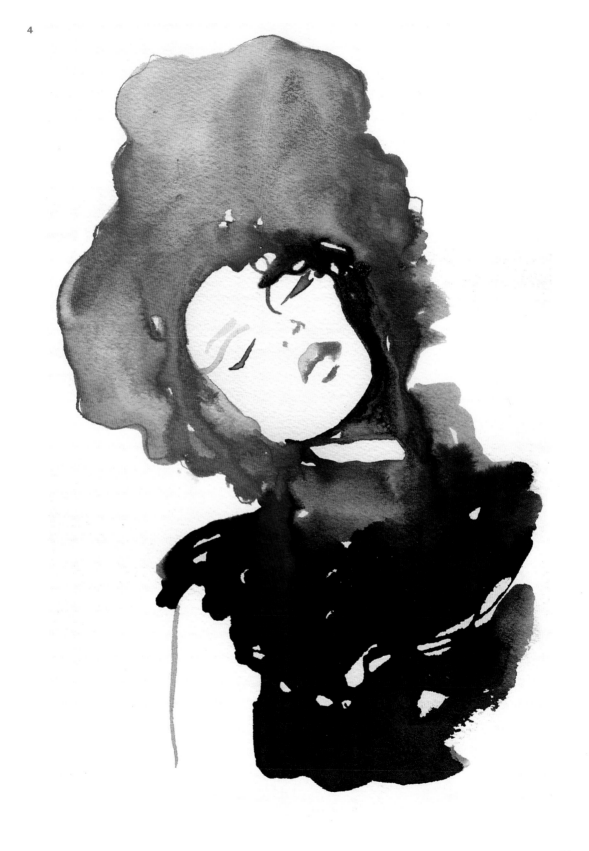

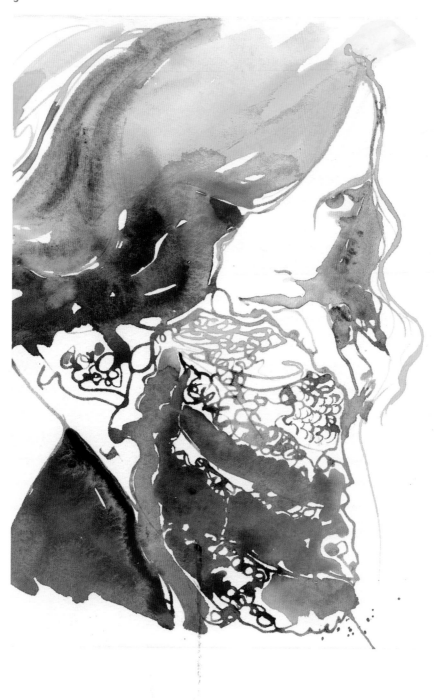

5 *Marion*, 2011
Watercolor with ink
13 × 11 in. (33 × 28 cm)

6 *Amber*, 2010
Watercolor with ink on tissue paper
10 × 8 in. (25 × 20 cm)

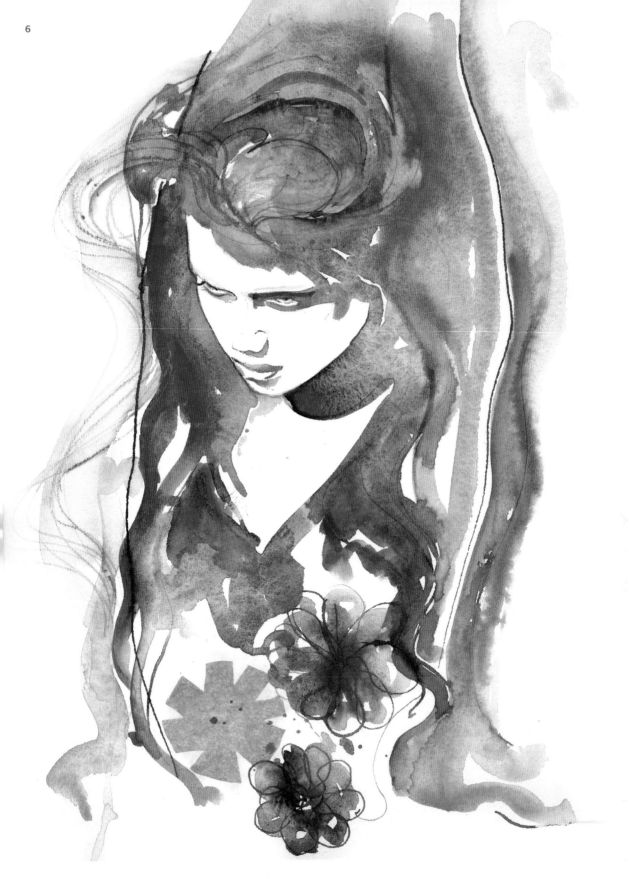

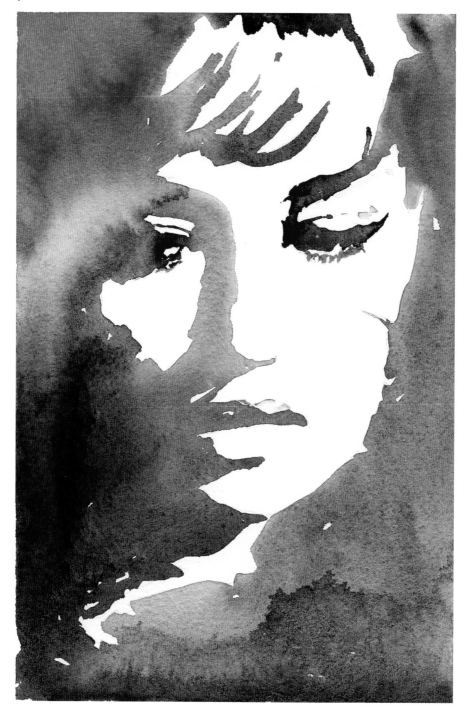

7 *Jeanne Moireau*, 2010
Watercolor
15 × 11 in. (38 × 28 cm)

8 *Maison*, 2011
Watercolor
22 × 15 in. (56 × 38 cm)

ISADORA REIMÃO

Isadora Reimão likes to define her paintings of animals and monsters as "nonhuman self-portraits." She says, "I like the antitheses of fascination-fear, beauty-nightmare, and sweet-terrible. Some of my recent illustrations are my visual interpretation of characters from Mário de Andrade's story *Macunaíma*. And other illustrations may be a start for new stories."

1

1 *Lis*, 2011
Isadora Reimão
Watercolor
8 × 7 in. (20 × 18 cm)

2 *Beetle*, 2011
Isadora Reimão
Watercolor
11½ × 7½ in. (29 × 19 cm)

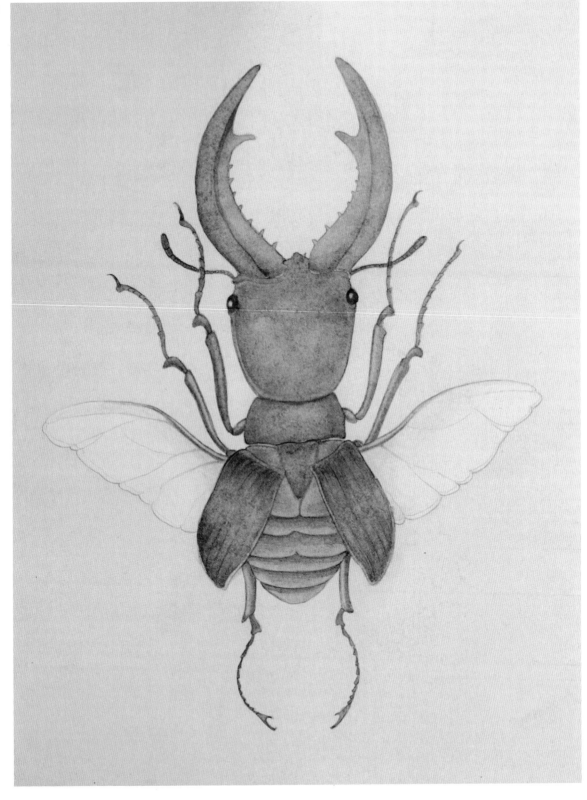

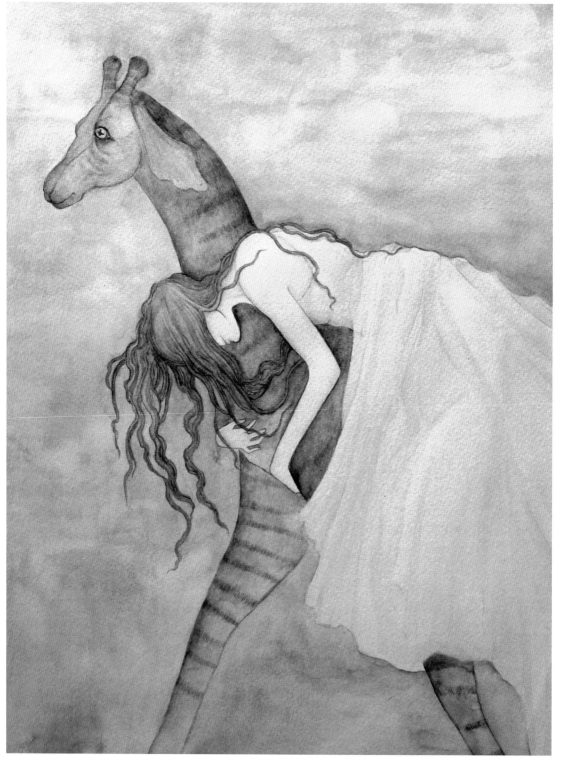

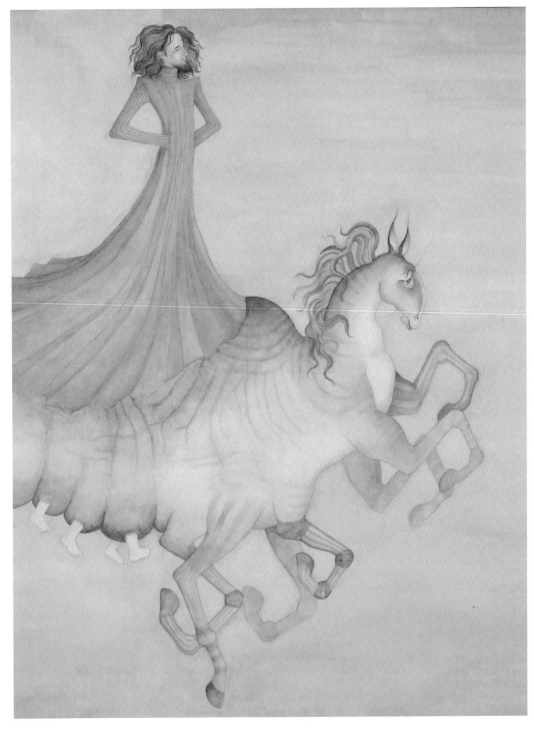

3 *The Blue Giraffe*, 2007
Watercolor
17½ × 15 in. (45 × 38 cm)

4 *The Horse Man*, 2006
Watercolor
25 × 35½ in. (64 × 90 cm)

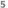

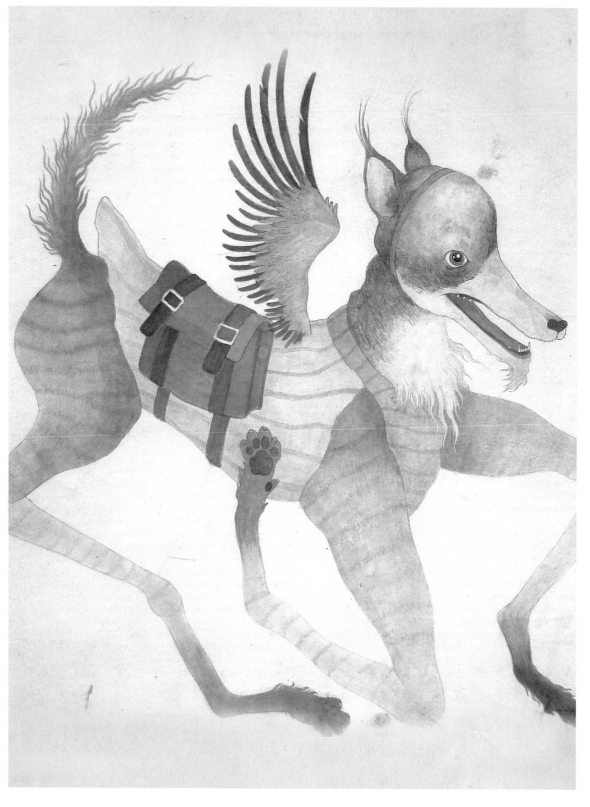

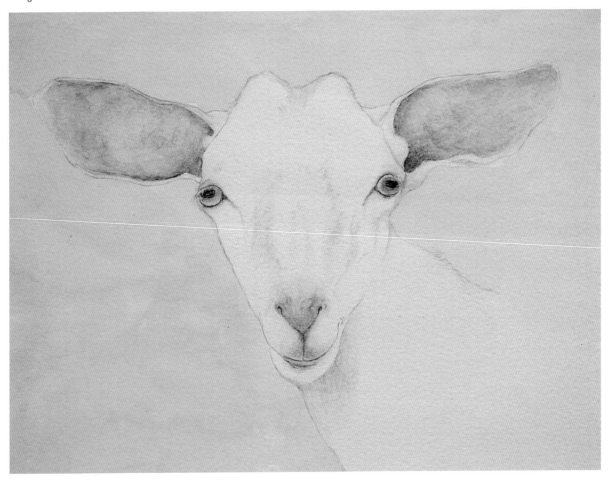

5 *Ranulpho*, 2004
Watercolor
16½ × 22 in. (42 × 56 cm)

6 *She-Goat*, 2007
Watercolor
8 × 9 in (20 × 22 cm)

SUJEAN RIM

Fashion inspires Sujean Rim's illustrations, which depict a stylish and whimsical world of characters. Her paintings are colorful, but never fussy—which the artist says reflects her personal style. She finds watercolor to be the perfect medium to express herself in.

1

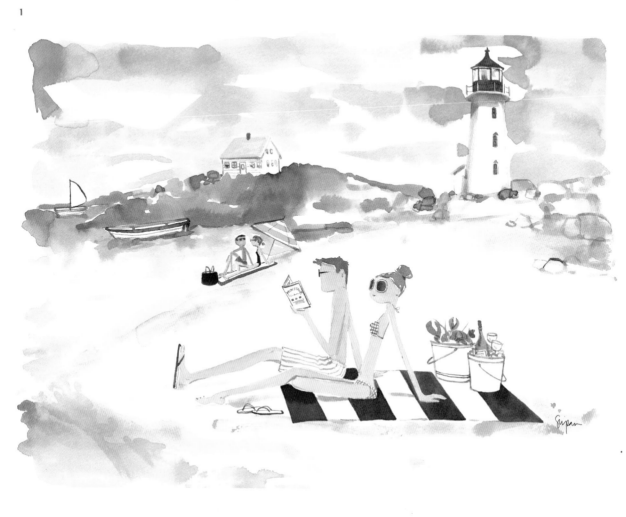

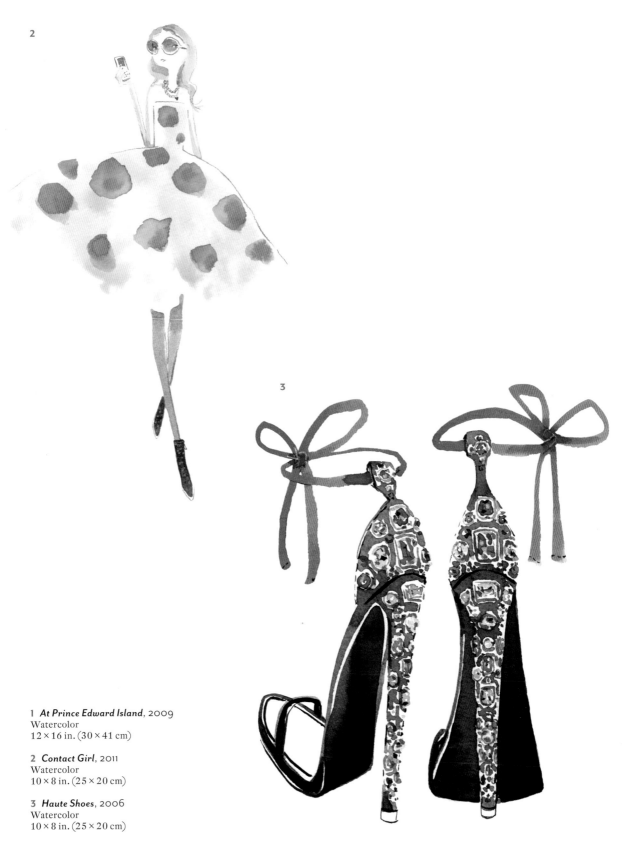

2

1 *At Prince Edward Island*, 2009
Watercolor
12 × 16 in. (30 × 41 cm)

2 *Contact Girl*, 2011
Watercolor
10 × 8 in. (25 × 20 cm)

3 *Haute Shoes*, 2006
Watercolor
10 × 8 in. (25 × 20 cm)

3

4 *Believe It. Do It*, 2011
Watercolor
10×16 in. $(25 \times 41$ cm$)$

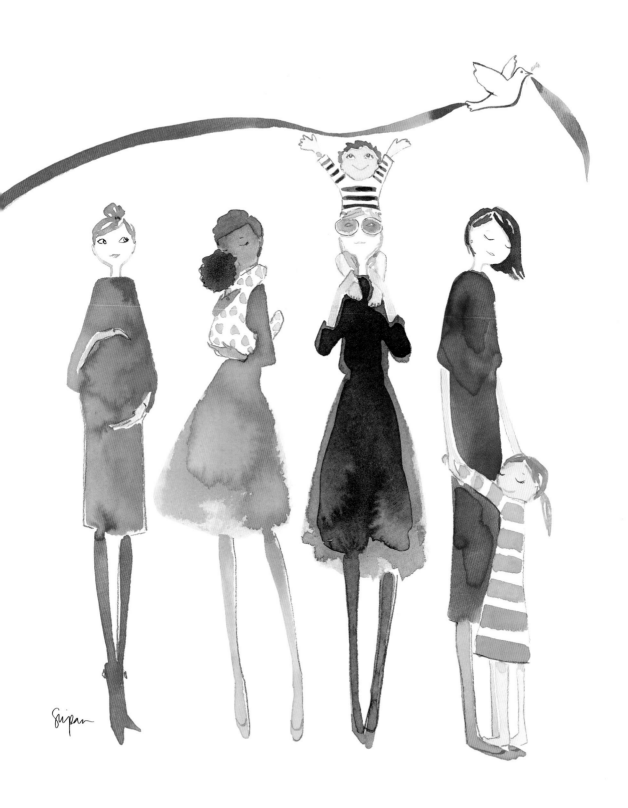

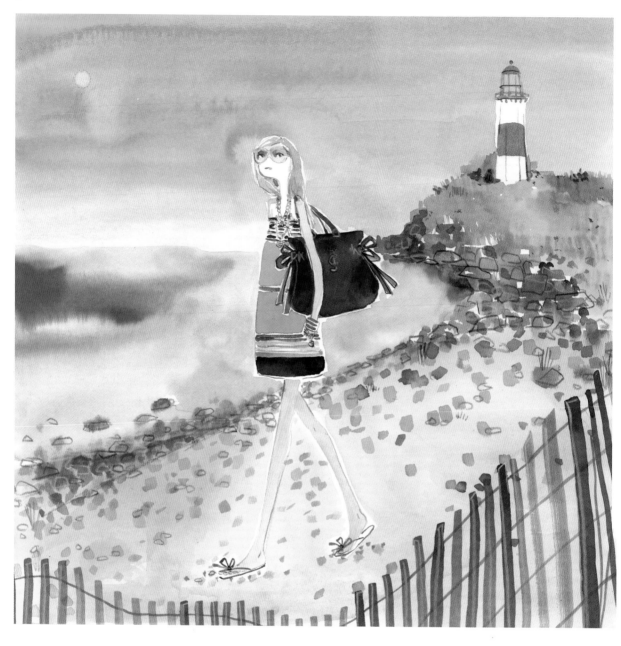

6 *Hibiscus*, 2010
Watercolor
8 × 10 in. (20 × 25 cm)

5 *Montauk*, 2011
Watercolor
14 × 14 in. (36 × 36 cm)

7 *Surf's Up*, 2011
Watercolor
14 × 14 in. (36 × 36 cm)

6

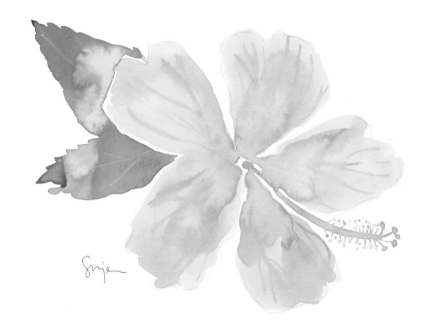

7

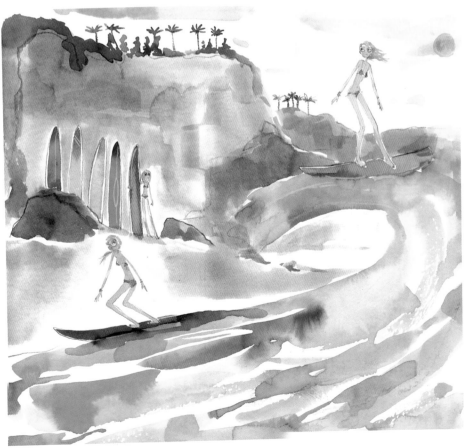

AMY ROSS

Amy Ross's art is informed by her background in religious studies and by her interest in folklore and mythology. She is drawn to stories, both factual and fantastical, that provide explanations for the phenomena of the natural world. Ross states: "I am interested in the idea of artist as mad scientist, and in my paintings I conflate flora and fauna to create surrealistic hybrid creatures, thereby offering my vision of an *un*natural world. In my most recent work, I use human and animal imagery, particularly wolves, to examine experiences that are both personal and global. I am curious about the dichotomy of public persona versus private identity, and of the individual versus the group—or the lone wolf versus the pack. This series of work has been strongly influenced by stories of shape-shifting, wherein people are transformed, voluntarily or not, into animal form."

1 *Totem*, 2011
Watercolor
11 × 15 in. (28 × 38 cm)

2 *Flotsam*, 2011
Watercolor
15 × 11 in. (38 × 28 cm)

1

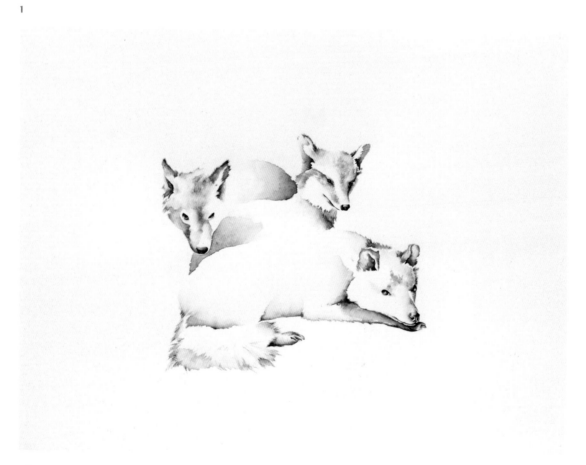

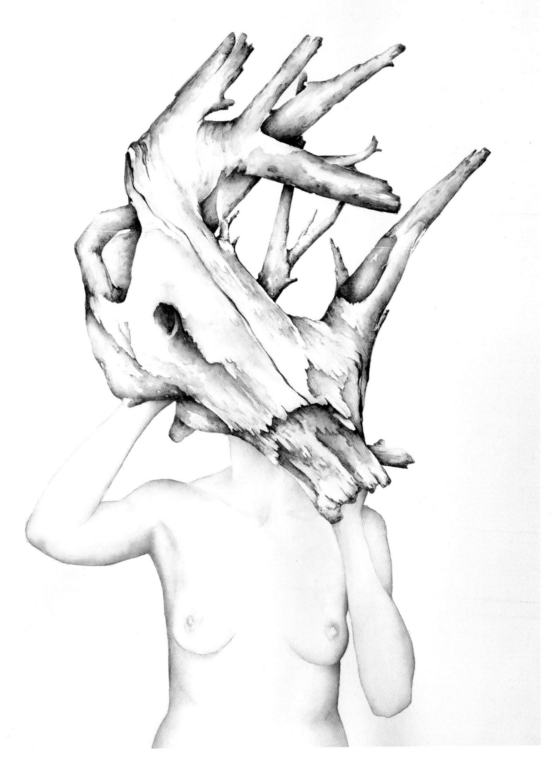

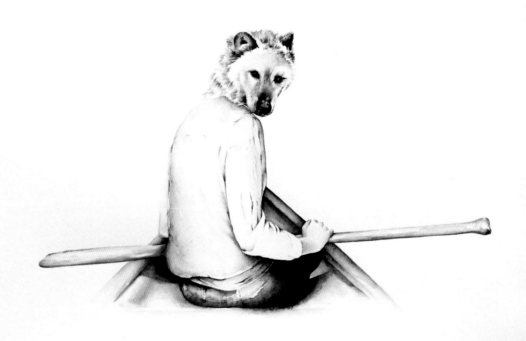

3 Day Tripper, 2011
Watercolor
11 × 15 in. (28 × 38 cm)

4 Secrets of Living #3, 2009
Watercolor
22 × 15 in. (56 × 38 cm)

5 Bounty, 2011
Watercolor
15 × 11 in. (38 × 28 cm)

6 Brother Wolf #1, 2010
Watercolor
22 × 15 in. (56 × 38 cm)

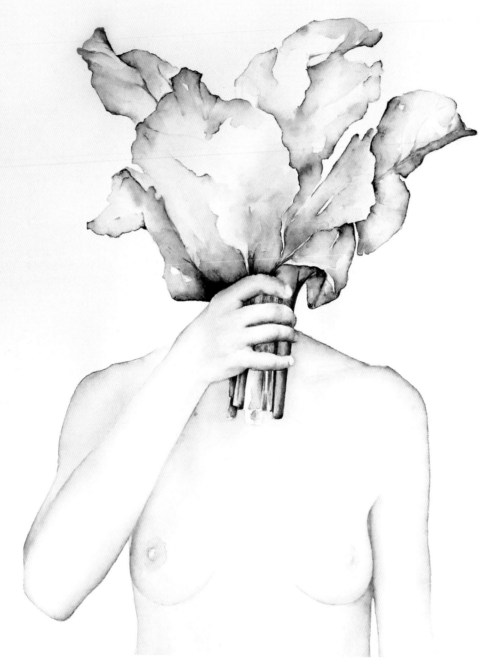

WATERCOLOR

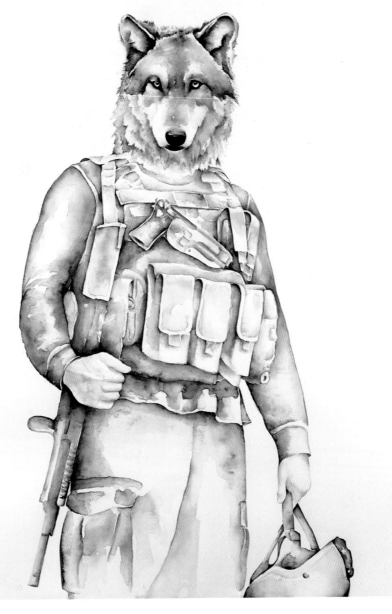

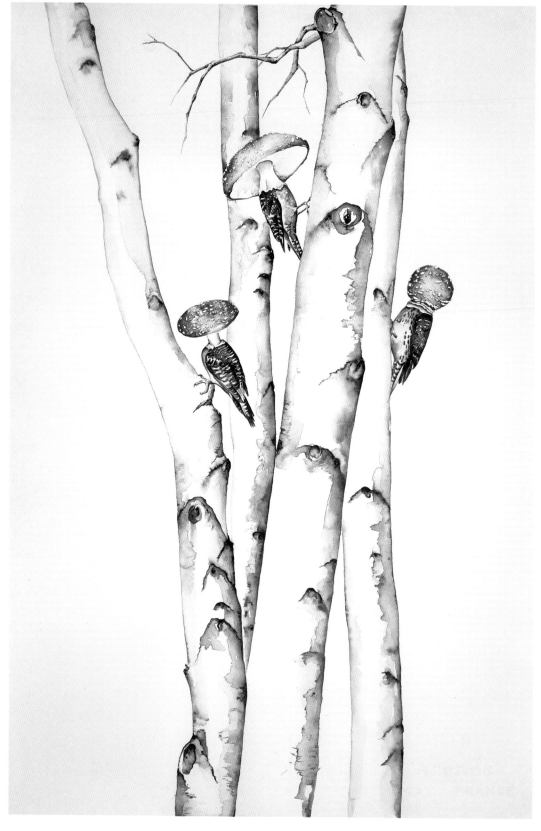

WATERCOLOR

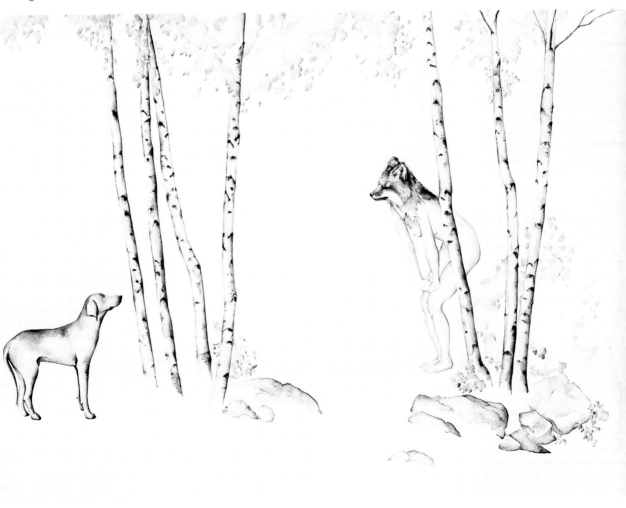

7 *Woodpeckershrooms*, 2009
Watercolor
30 × 22 in. (76 × 56 cm)

8 *Fox Hunting*, 2009
Watercolor
13 × 19 in. (33 × 48 cm)

JOSÉ SELIGSON

José Seligson's primary interest has always been color and texture more than form or content, so when he first experimented with watercolor and discovered how it could be manipulated with various tools on different surfaces, a whole new world of art possibilities opened up. He began to use tools such as sponges, syringes, rubbing alcohol, spray bottles, coffee filters, nonporous paper, chopsticks, and anything else he could find to create his compositions. After years of assiduously avoiding the medium, he declares, "I was smitten." In his words, watercolor enables the "color to come to life in ways that other media do not permit, and the textures are of an idiosyncratic nature."

1 *Quilt*, 2008
Watercolor on YUPO synthetic paper
20 × 26 in. (51 × 66 cm)

2 *Jonny*, 2004
Watercolor
24 × 18 in. (61 × 46 cm)

1

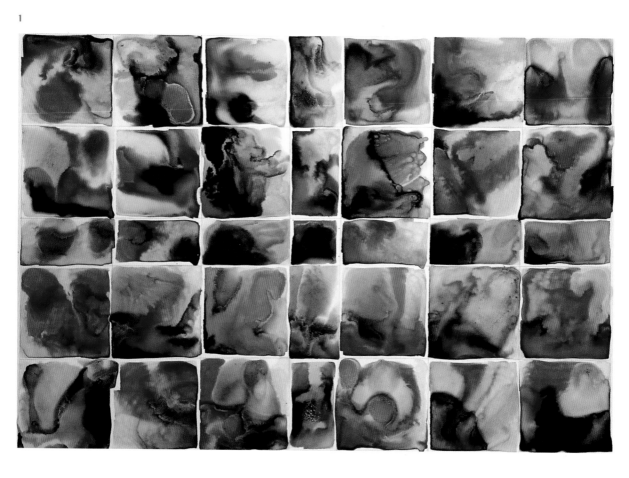

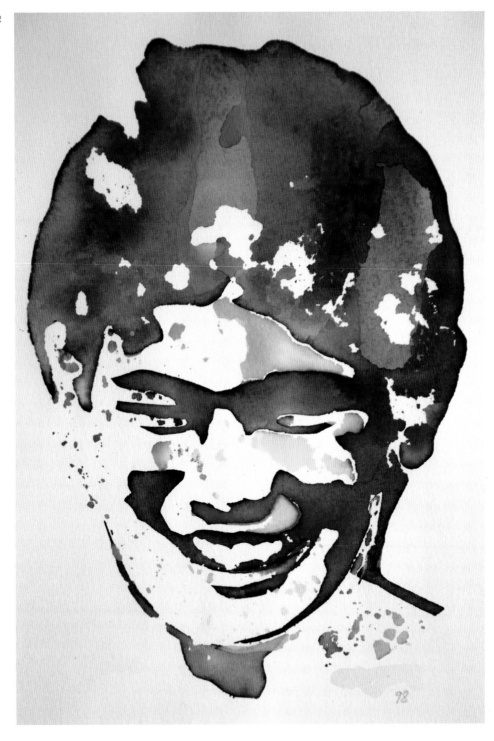

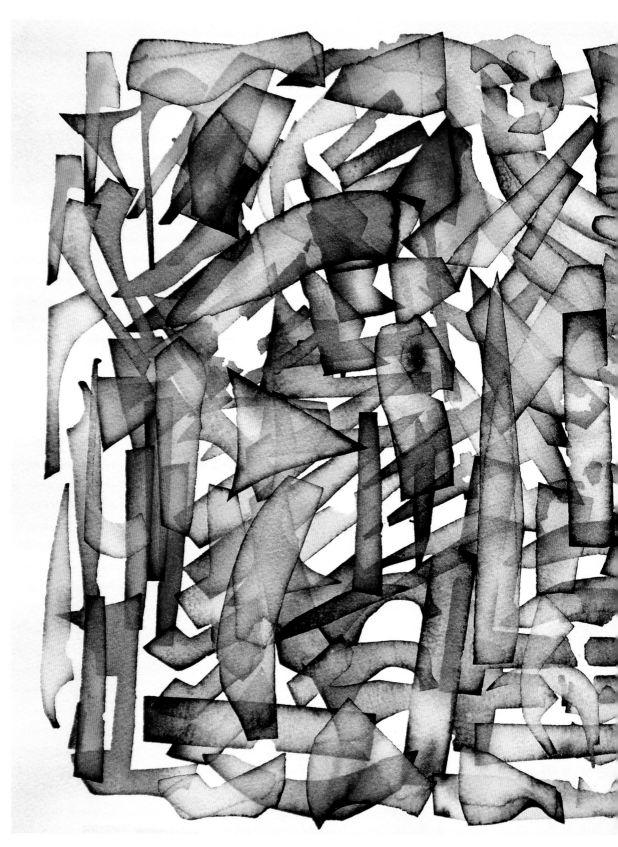

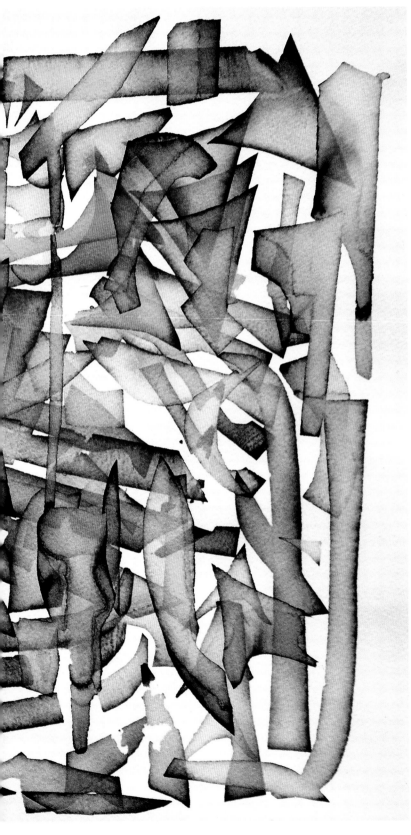

3 *Traffic*, 2002
Watercolor
14 × 18 in. (36 × 46 cm)

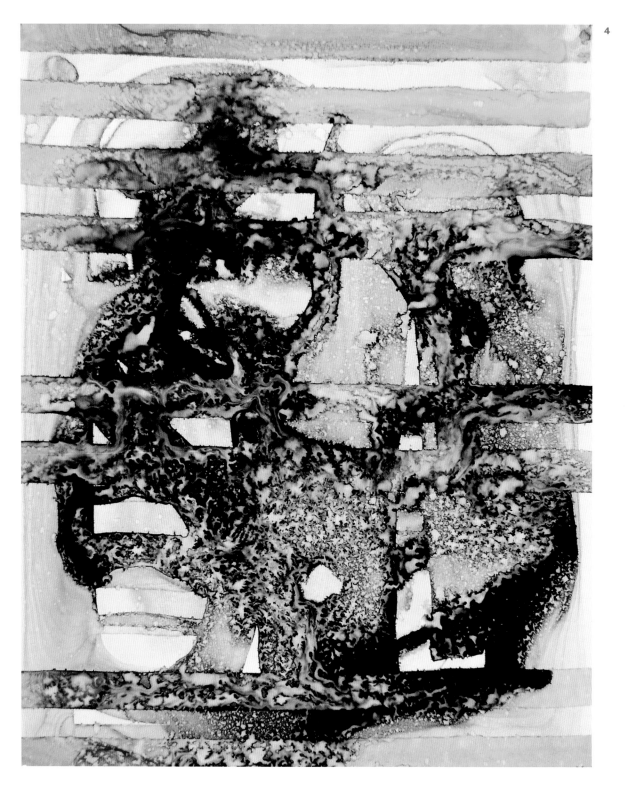

WATERCOLOR

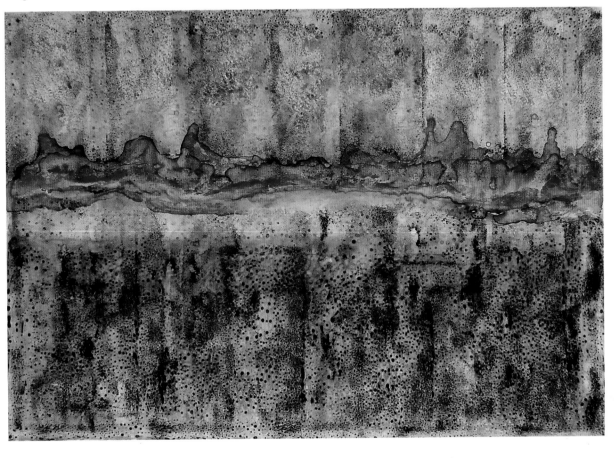

4 *Baobab*, 2009
Watercolor on YUPO synthetic paper
16 × 14 in. (41 × 36 cm)

5 *Julie OMG*, 2008
Watercolor on YUPO synthetic paper
20 × 26 in. (51 × 66 cm)

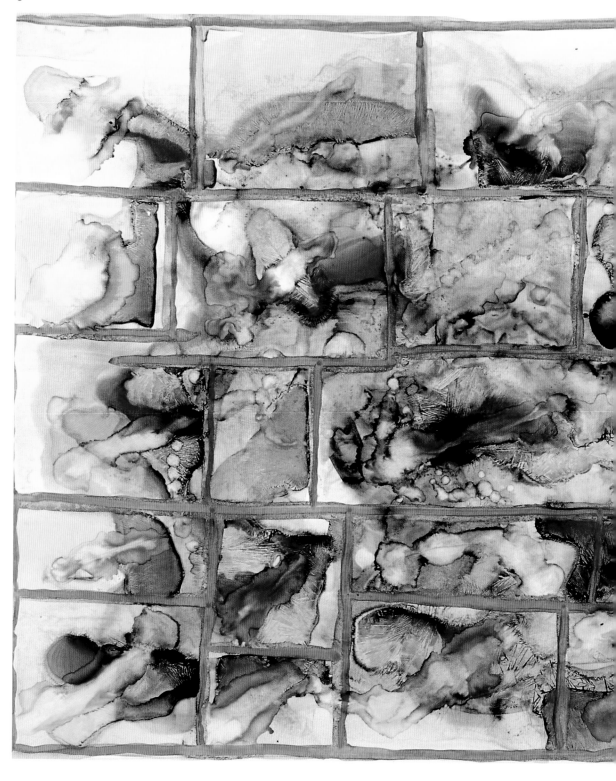

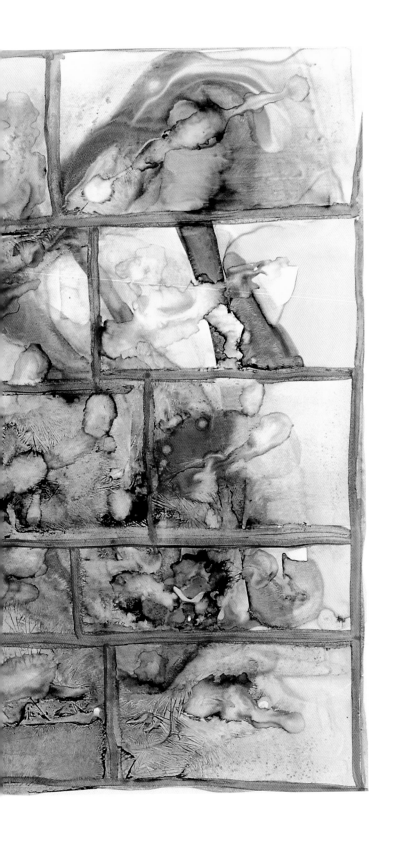

6 *Bricks*, 2007
Watercolor on YUPO synthetic paper
20 × 26 in. (51 × 66 cm)

BECCA STADTLANDER

Becca Stadtlander's aesthetic is based on an appreciation of folk art and pastoral imagery; this inspires her work and guides her style and identity as an illustrator. Using watercolor and gouache, she makes small paintings that depict a poetic visual narrative through texture, color, pattern, and intricacy. Stadtlander says, "Creating a feeling on paper is the challenge I start with in every piece. Whether it be the particular season, weather, or wallpaper, every environment has an unexplainable essence all its own. I am dedicated to creating the timeless and simple images that I love."

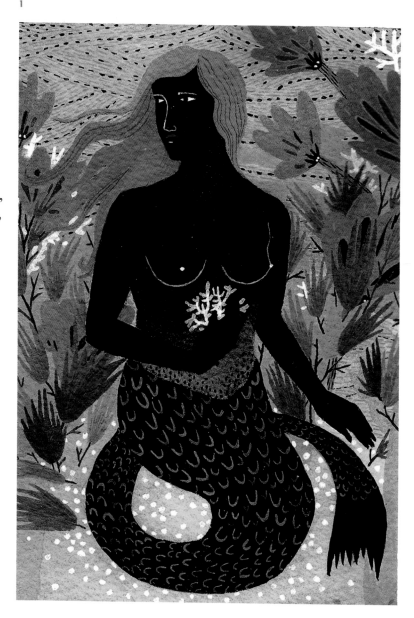

1 *Mermaid*, 2011
Gouache
6½ × 4½ in. (17 × 11 cm)

2 *Champèr*, 2010
Watercolor and gouache
10 × 8 in. (25 × 20 cm)

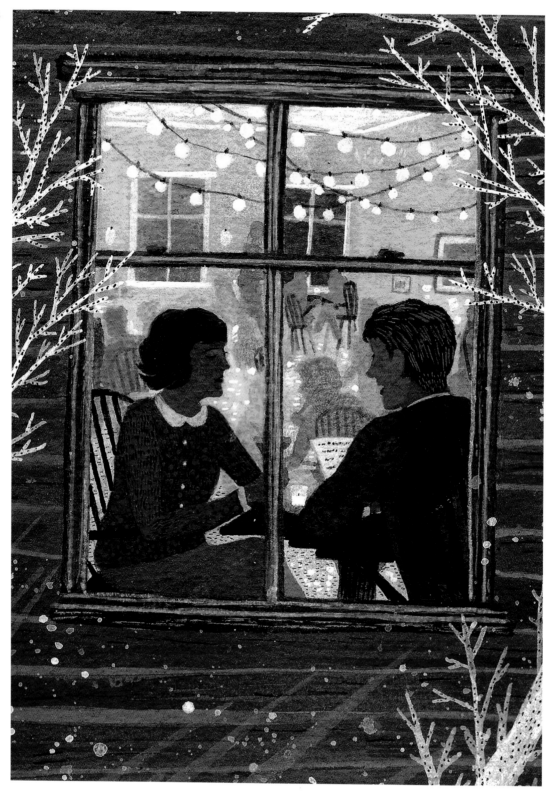

3 *Dinner Date*, 2011
Gouache
7 × 5 in. (18 × 13 cm)

4 *Garden Variety*, 2011
Watercolor and gouache
6 × 4 in. (15 × 10 cm)

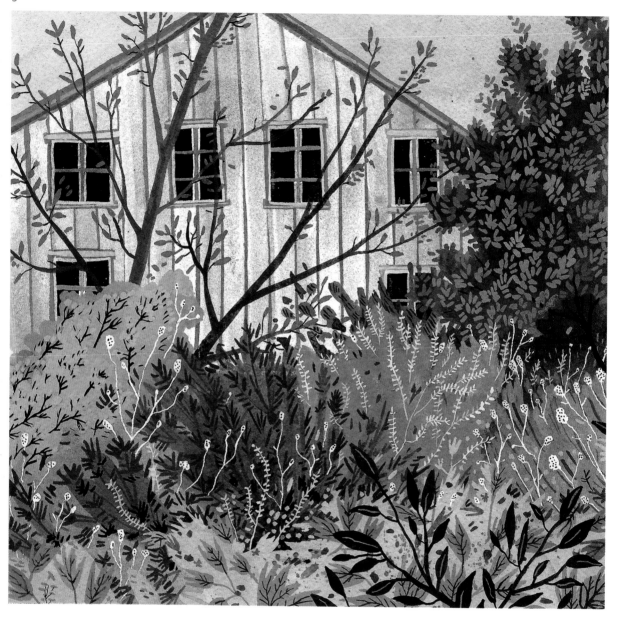

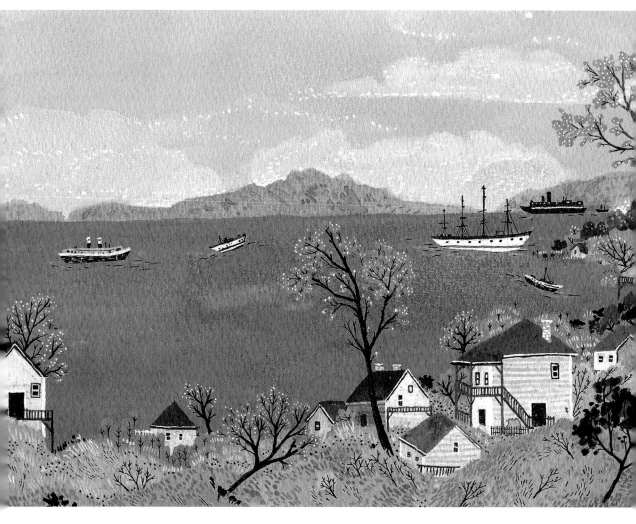

5 *Overgrown Garden*, 2011
Gouache
7 ½ × 7 ½ in. (19 × 19 cm)

6 *Summer*, 2011
Watercolor and gouache
5 × 7 in. (13 × 18 cm)

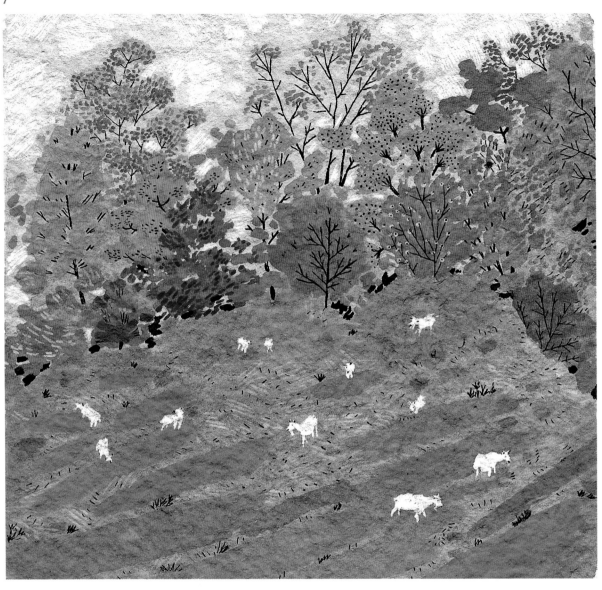

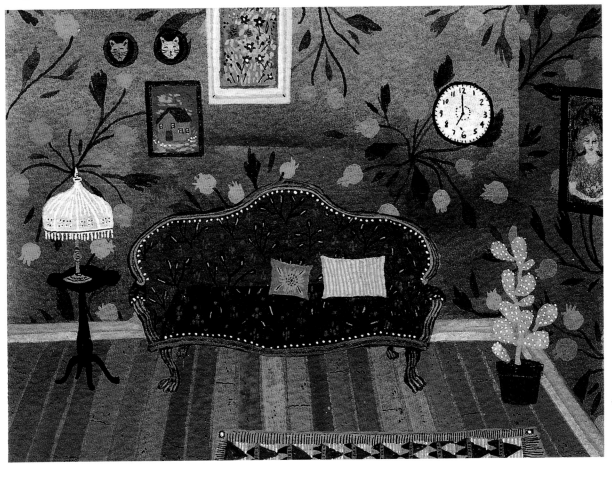

7 *Goats*, 2010
Gouache
7 × 7 in. (18 × 18 cm)

8 *Living Room*, 2011
Watercolor and gouache
3 × 4 in. (8 × 10 cm)

JOHN NORMAN STEWART

John Norman Stewart feels that he must be discovering something when he is working. Sometimes this is a struggle, but it is mostly an enjoyable process. Stewart likes to venture outside of his comfort zones, often beginning with little preplanning, especially when working with abstraction. Abstraction, in his words, is "very freeing, maybe like hang-gliding or diving off a three-meter board as a member of the high-school swim team." He is also affected by his choices of materials and colors, such as "what a drop of phthalo blue does next to orange in a puddle of water on the surface of the paper." His favorite medium is watercolor, partly because of its unpredictable behavior, but he works in various media and styles. "To me," says Stewart, "diversity equals freedom and artistic exploration."

1

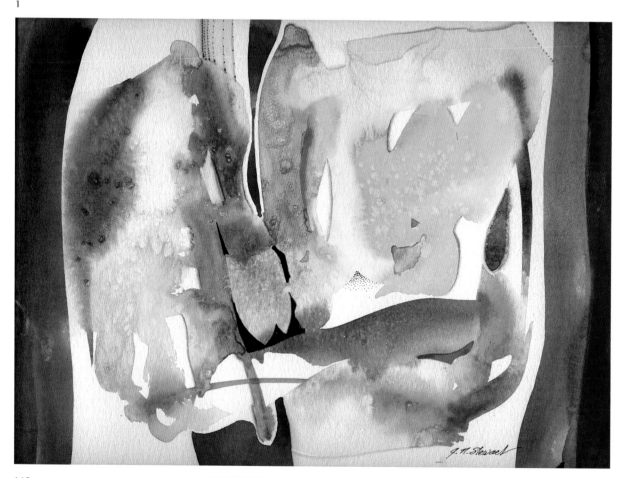

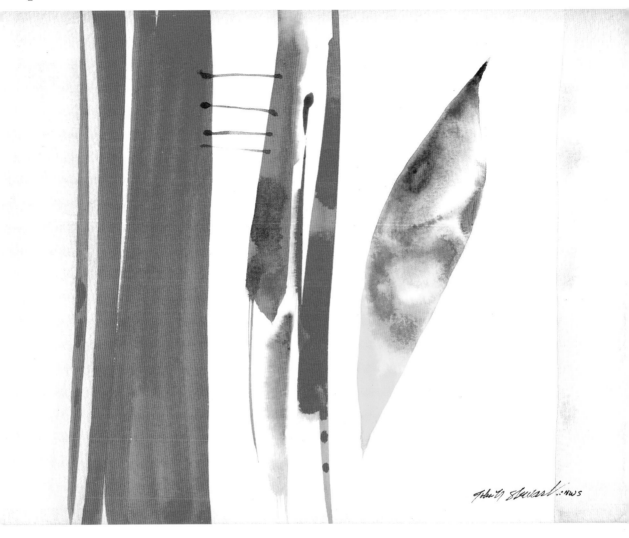

1 *Fluidity*, 2011
Watercolor
9 × 12 in. (23 × 30 cm)

2 *Leaf Red Bar*, 2009
Watercolor
11 × 14 in. (28 × 36 cm)

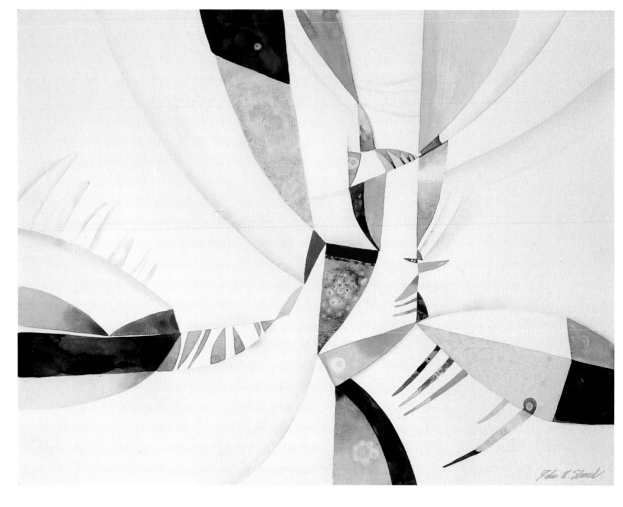

3 *Shards*, 2010
Watercolor
14¾ × 19¾ in. (38 × 51 cm)

4 *Mechanica*, 1993
Watercolor
11¾ × 9 in. (30 × 23 cm)

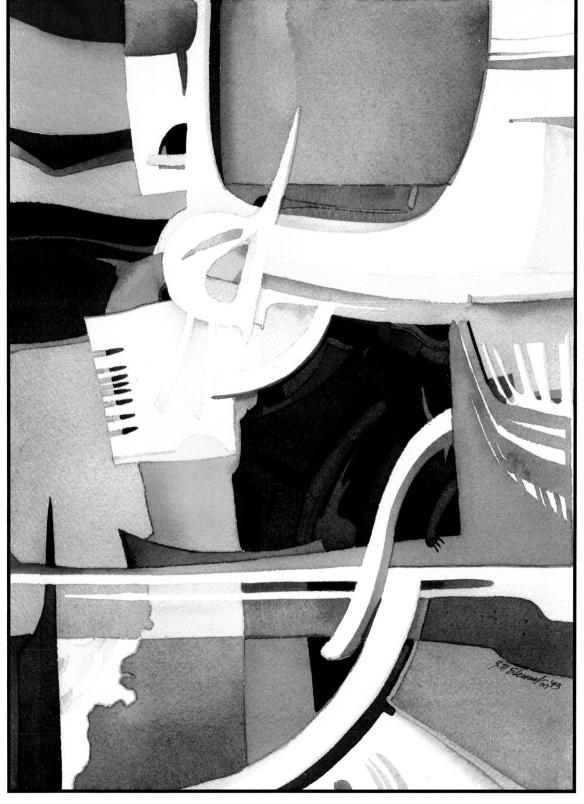

JOHN NORMAN STEWART

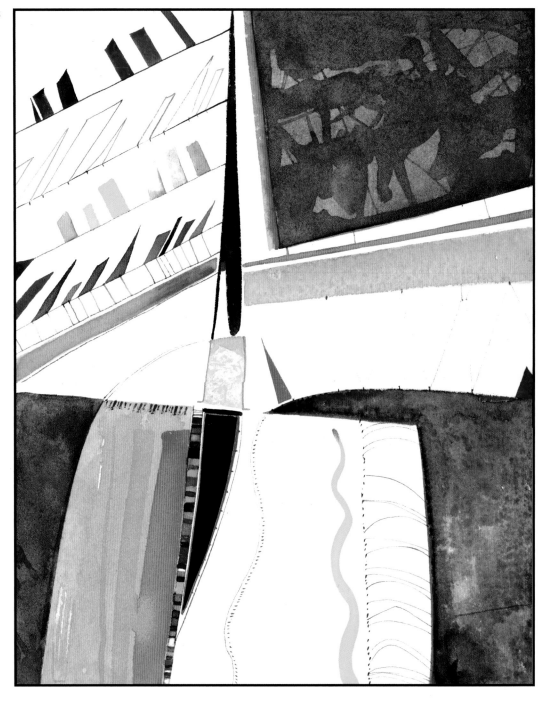

5 *Piano Keys*, 1997
Watercolor
14 × 11 in. (36 × 28 cm)

6 *Mechanica 2*, 2008
Watercolor
12 × 9 in. (30 × 23 cm)

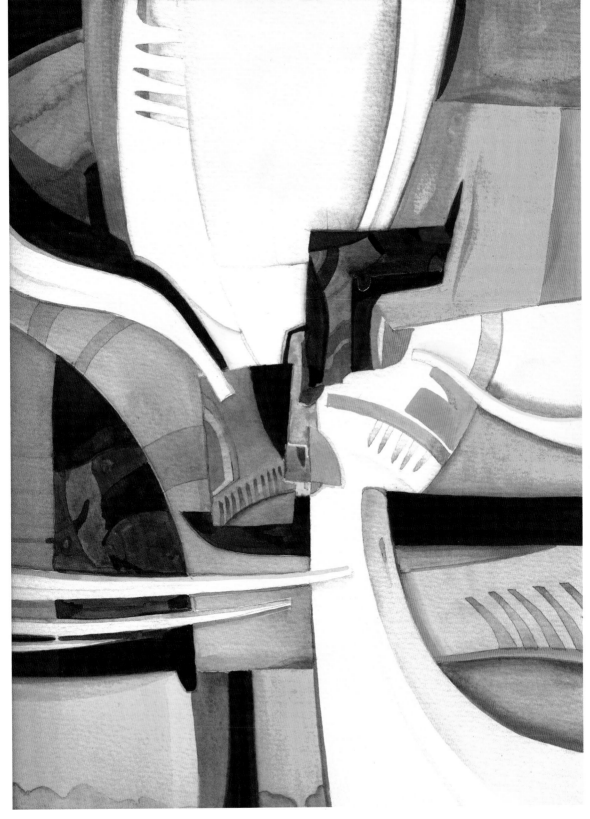

7 *Stones and Bones*, 2011
Watercolor
9 × 12 in. (23 × 30 cm)

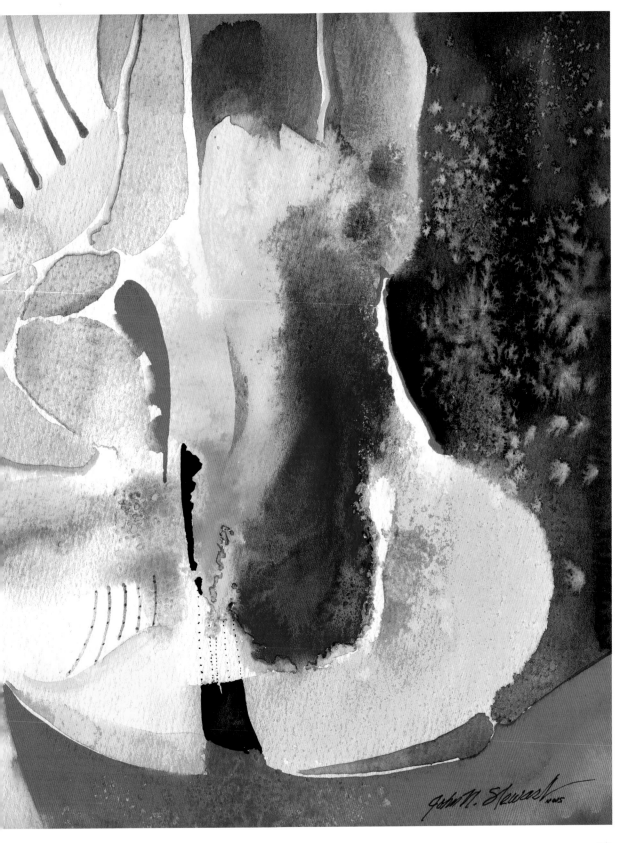

PAOLO TERDICH

Paolo Terdich's art is both realistic and mysterious. His painted human figures convey intimacy and psychology. Of his recent figurative work, Terdich says, "I try to exalt the light and its contrast with shadow through my fascination with form and attention to detail, texture, and atmosphere. My intention is to pick out the psychology of the characters and suffuse them with sensuality. My figures are never portrayed with other individuals, to emphasize the loneliness of the contemporary human being." On his paper and canvas supports, he wishes to capture "moments of lived life, analyzing existential problems, and trying to lead the observers to reflect."

1 *Water 10*, 2009
Watercolor
20 × 27 ½ in. (50 × 70 cm)

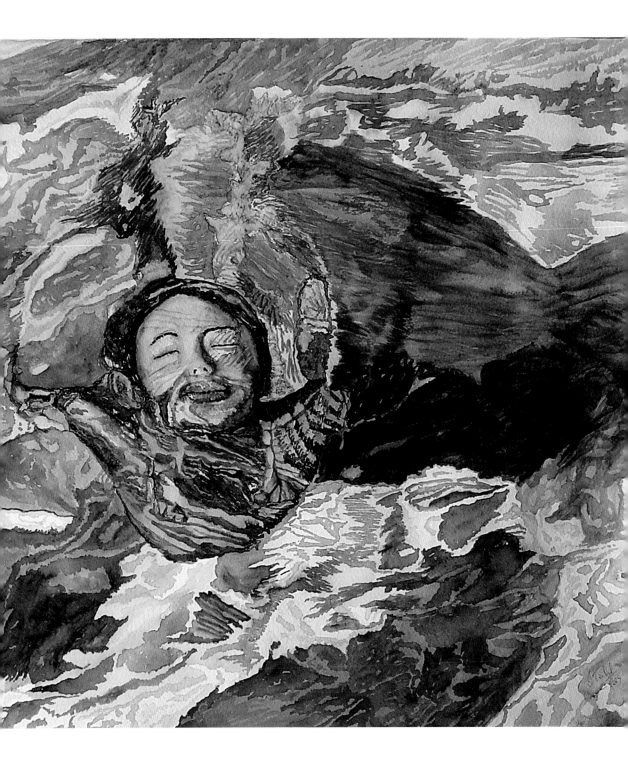

2 *Never Broken*, 1991
Watercolor
21½ × 21½ in. (55 × 55 cm)

3 *Petra*, 2001
Watercolor
22 × 15 in. (56 × 38 cm)

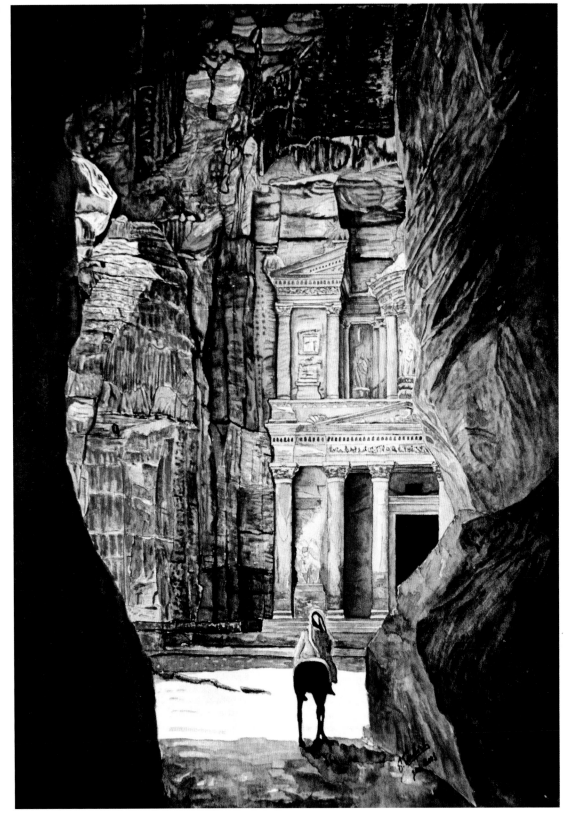

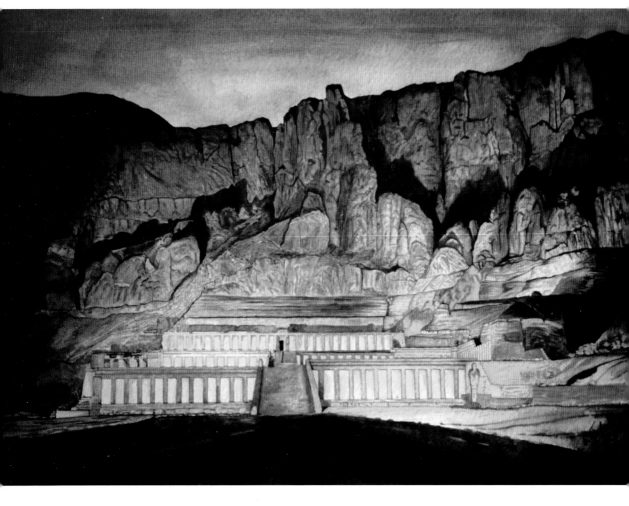

4 *Nubia 2*, 2000
Watercolor
14 × 12 in. (35 × 30 cm)

5 *Hatshepsut*, 2000
Watercolor
16 × 23½ in. (40 × 60 cm)

TAMARA THOMSEN

Whether in "rooms" found outdoors or under a roof, light, color, and patterns tumble into compositions that form unusual sorts of spaces in Tamara Thomsen's work. Cherry trees or carved woodwork are both equally and carefully rendered, without embellishment. As elements of horticulture or architecture, they encompass spacious areas in a world where frivolity overwhelms. Her large-scale watercolor paintings study these environments. *Entwine*, a series of landscapes are based on the Brooklyn Botanic Garden, and *Chambers* are a group of architectural interiors found in a 1769 colonial mansion in Philadelphia.

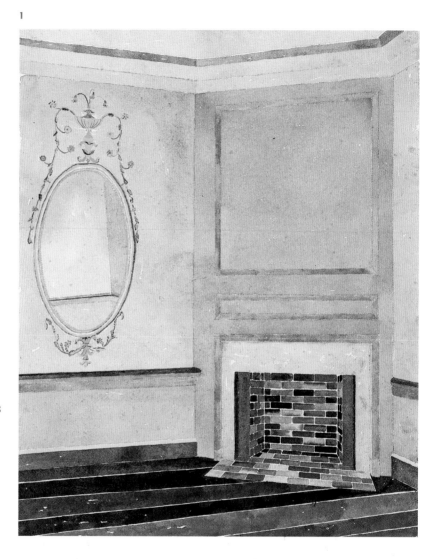

1

1 *West Bedroom*, 2008
Watercolor
34 × 29 in. (86 × 74 cm)

2 *Upper Hall Stair Landing*, 2008
Watercolor
40 × 26 in. (102 × 66 cm)

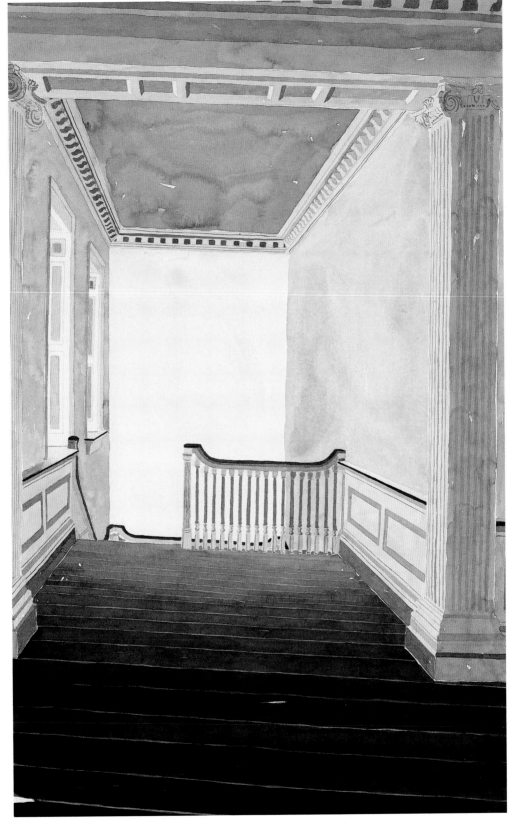

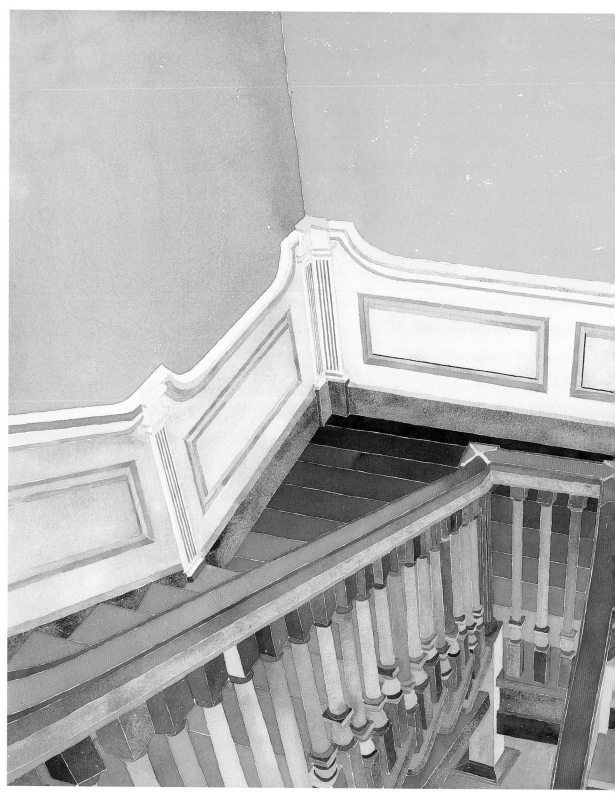

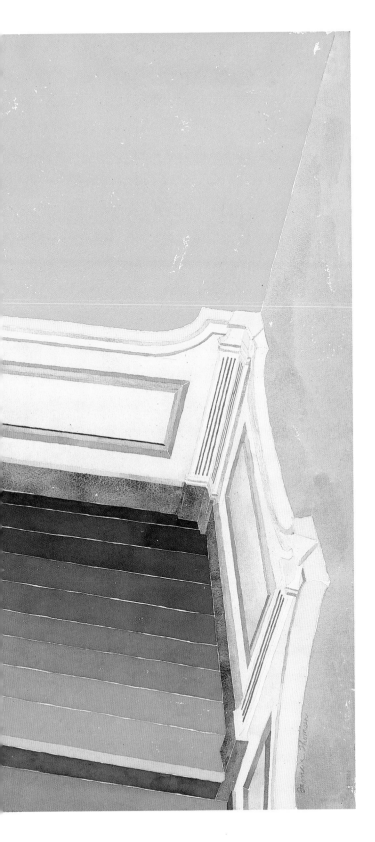

3 *Stairway*, 2008
Watercolor
34 × 47 in. (86 × 119 cm)

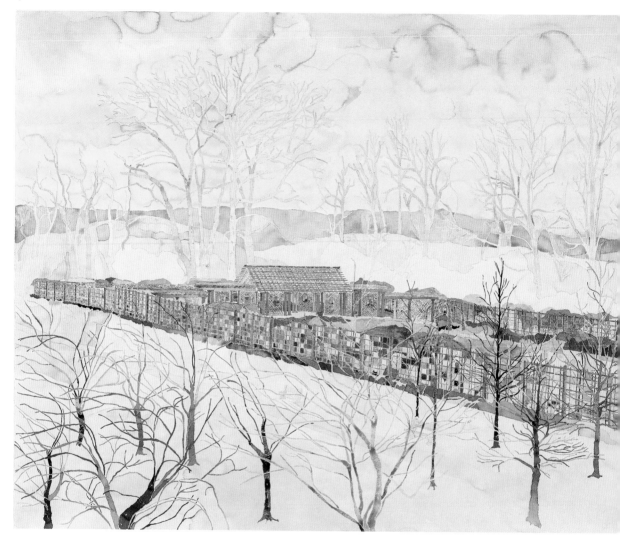

4 *January Crimsons*, 2011
Watercolor
45 × 57 in. (114 × 145 cm)

5 *Attic* (detail), 2008
Watercolor
26 × 39 in. (66 × 99 cm)

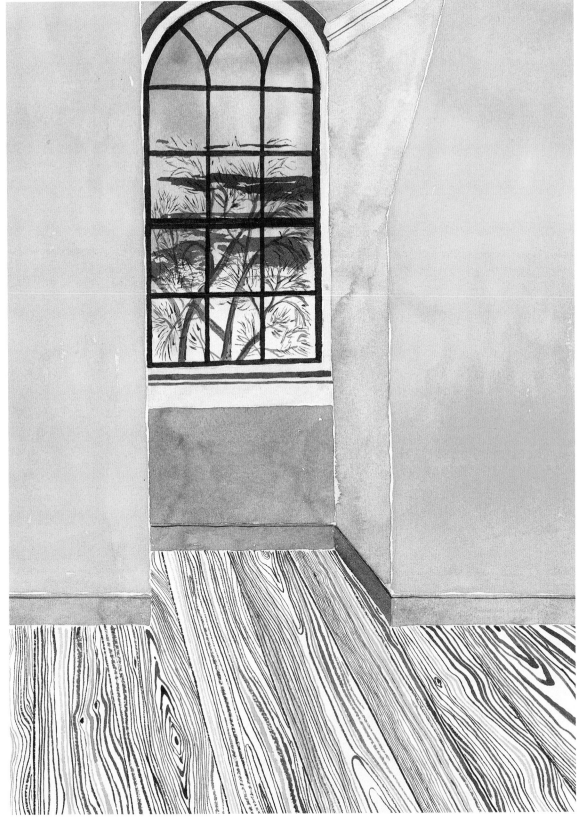

JENNY VORWALLER

Of her art, Jenny Vorwaller states: "I love to explore the many sides of water media. Watercolor has a multi-faceted personality, like a mystery that I will never solve—there is a thrill in the give and take that demands loss of control and an excitement in seeing the unanticipated results that come from the brush. Watercolors bring spontaneity and a feeling of surrender that comes when creating. I see painting as a continuous immersion into a language I call my own."

1 *Reflection*, 2011
Watercolor
9 × 12 in. (23 × 31 cm)

2 *Self Portrait*, 2011
Watercolor
14 × 10 in. (36 × 25 cm)

1

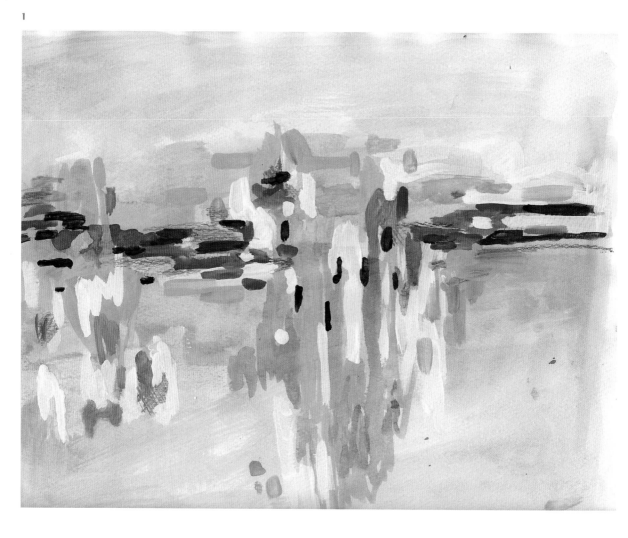

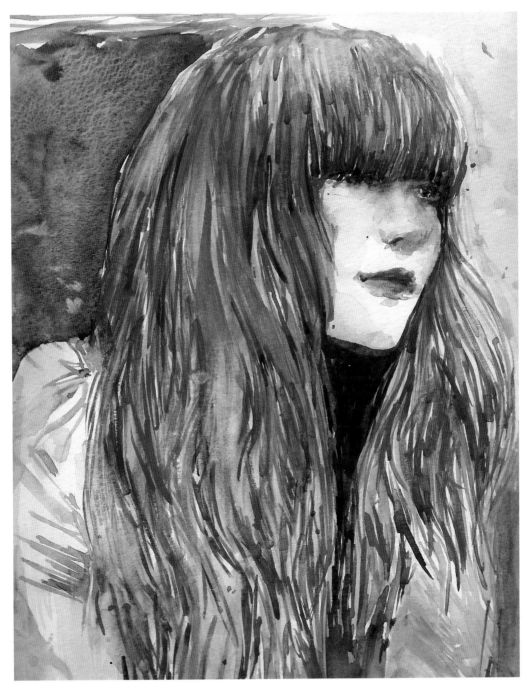

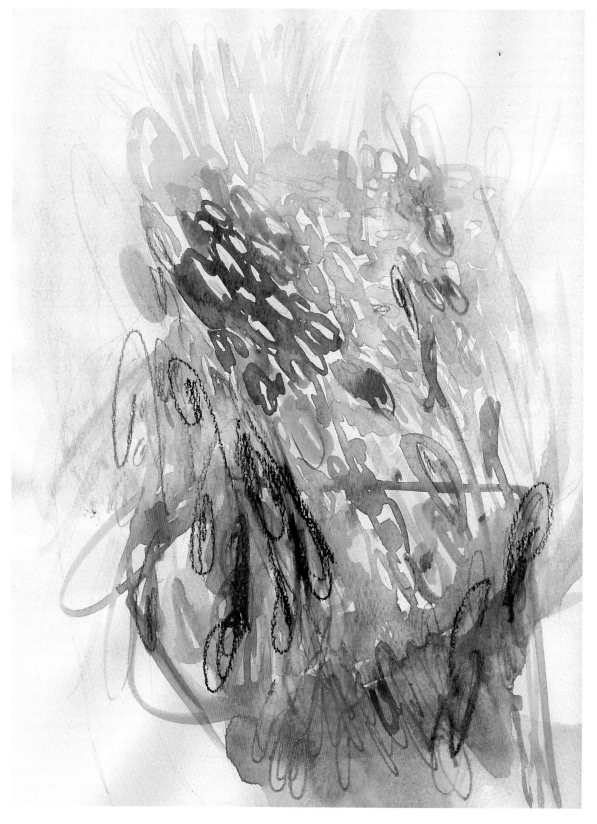

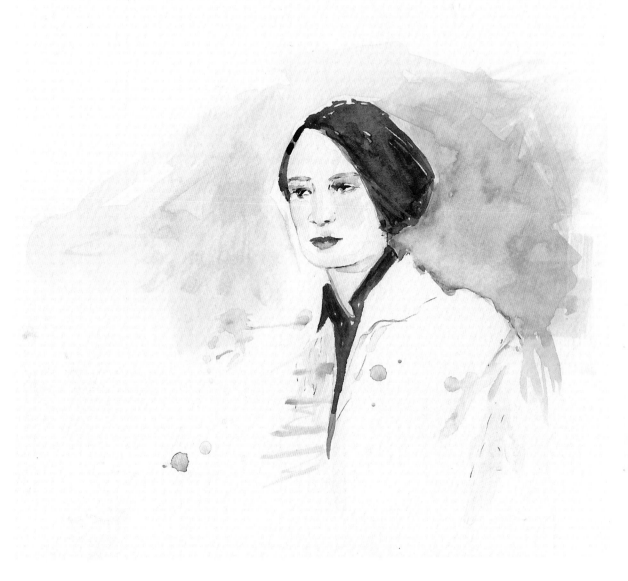

3 *Chance*, 2011
Watercolor with pencil and crayon
10 × 8 in. (25 × 20 cm)

4 *Vero*, 2011
Watercolor
5 × 7 in. (13 × 18 cm)

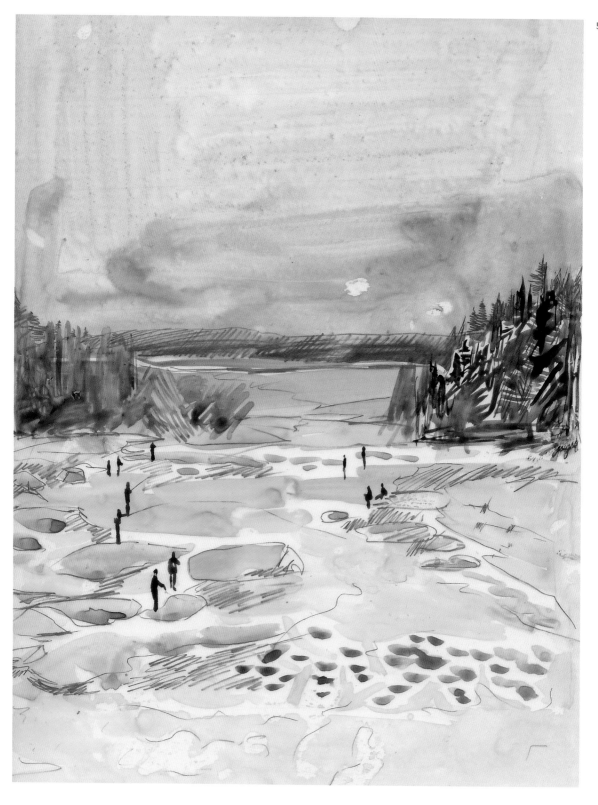

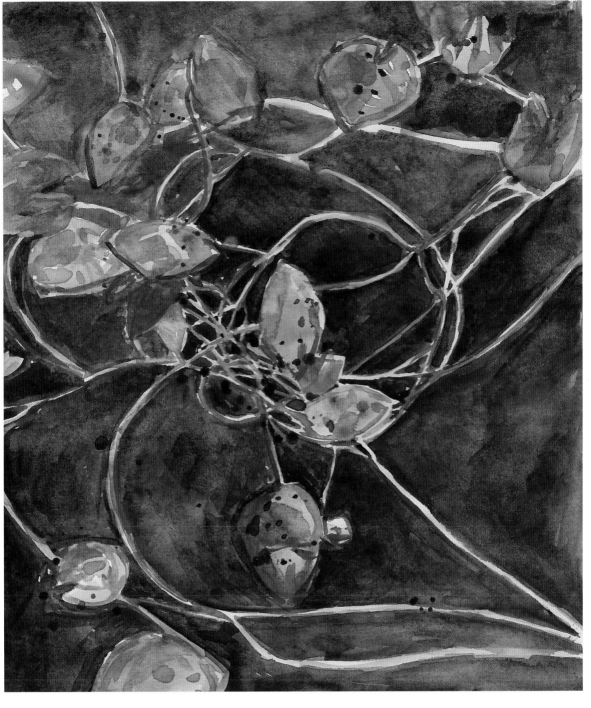

5 *Fly Fishermen*, 2011
Watercolor with pencil on YUPO
synthetic paper
12 × 9 in. (30 × 23 cm)

6 *Lily*, 2011
Watercolor
10 × 8 in. (25 × 20 cm)

HANNAH WARD

Hannah Ward's art grapples with the fusion of dualities: She is interested in relationships linking beauty and mutation, fragility and preservation, birth and decay, along with the myriad of processes in between. Her works reference dream imagery, childhood memories, and taxidermy. The woodland animals in her own surroundings have provided the artist with much of her inspiration. "These animals—deer, foxes, and rodents—form a totemic language through which I understand my environment," notes Ward. "Their forms suggest the vulnerability of the body and the ease with which it can be overwhelmed or transformed. My work is a conglomeration of the elegant and the bitter, of power and helplessness, of guilt and necessity. Within these accumulations of fur, tissue, and eyes, these creatures and forms have become my justification for a world that naturally blends hope and suffering. They are primal sensations of curiosity—the moments I've not yet found words for."

1

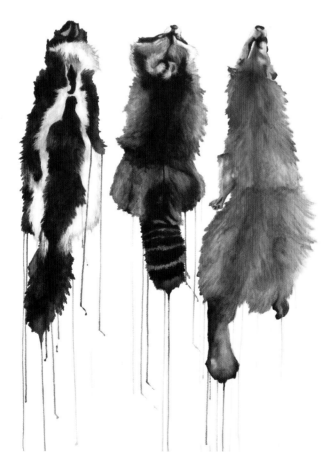

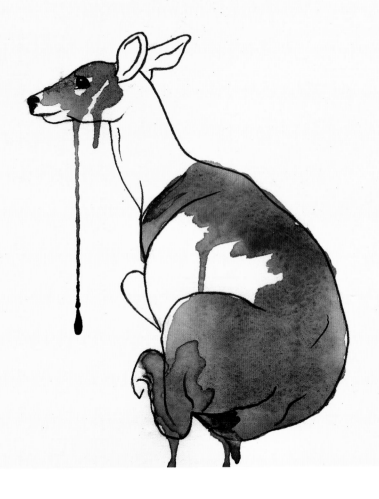

1 *Haunted*, 2011
Watercolor with watercolor pencil
38 × 50 in. (97 × 127 cm)

2 *Drain I*, 2011
Watercolor with ink
9 × 7 in. (23 × 18 cm)

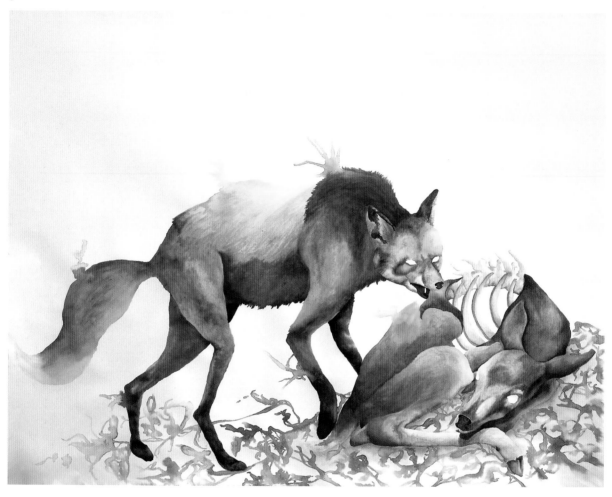

3 *The Uneasy Constant*, 2011
Watercolor and gouache
38 × 50 in. (97 × 127 cm)

4 *Comfort*, 2010
Watercolor with watercolor pencil and pen
14 × 18 in. (36 × 46 cm)

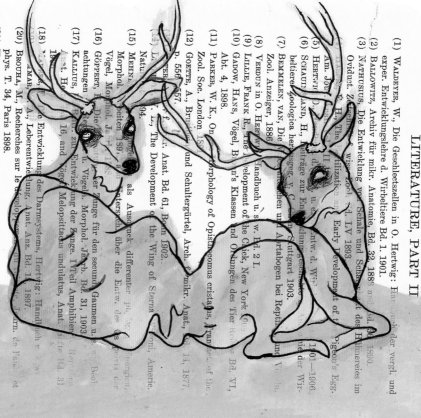

5 *Forever and Ever*, 2011
Watercolor with pen on found text
6 × 8 in. (15 × 20 cm)

6 *These Things I Long For*, 2011
Watercolor with colored pencil
25 × 19 in. (64 × 48 cm)

6

HANNAH WARD

Artist Bios

Gwendolyn Mason and Earnest Merritt (**DEAR HANCOCK**) earned their master's of fine art degrees from CalArts, in Valencia, California. Mason also holds a BFA in painting from the School of the Art Institute of Chicago, and Merritt holds a BFA in painting from The Cleveland Institute of Art. The pair formed Dear Hancock Paper Goods in the Los Angeles area in December 2010. Their website is www.dearhancock.com.

JULIA DENOS is a fashion and children's book illustrator; she works from her home studio in Quincy, Massachusetts. Her award-winning picture books include *Grandma's Gloves*, *I Had a Favorite Dress*, and *Just Being Audrey* (a biography for children about Audrey Hepburn's life). When Denos isn't at her painting desk, she can be found shopping for color, researching genealogy, or plotting her next travel excursion. Find more of her art and her blog at www.juliadenos.com.

DANNY GREGORY was born in London and spent his childhood traveling the world, from Pakistan to Australia to Israel to New York. He majored in politics at Princeton University and has had a successful career in advertising. He began making art in his thirties and has published many best-selling books on drawing and creativity, including *Everyday Matters*, *The Creative License*, *An Illustrated Life*, *A Kiss Before You Go*, and *An Illustrated Journey*. More of his work can be seen on his website, www.dannygregory.com.

SAMANTHA HAHN illustrates for various clients, including the magazines *Condé Nast Traveler*, *Glamour*, *Milk X*, *Marie Claire*, *Surface*, and *Prevention*; the stores APM, Anthropologie, and Barnes & Noble; and other companies including 2K, Brand New School, Galison, Johnson & Johnson, Random House, Saatchi & Saatchi,

Sakura Bloom, St. Martin's Press, and Victoria's Secret. Hahn's art and design book features include *The Bust DIY Guide to Life* and *Print and Pattern*. Her work has been exhibited in solo and group shows in the United States and Asia; she is represented by Gallery Hanahou. Hahn holds a BFA in illustration from Syracuse University and an MA in art education from Columbia University. She lives in Manhattan with her husband and child. For more of her work, her blog, "Maquette," can be found here: www.samanthahahn.com/blog.

VIRGINIA JOHNSON is a Canadian textile designer and illustrator whose colorful prints decorate clothing, shawls, and a home collection. Johnson attended New York's Parsons School of Design and worked for designer Helmut Lang before founding her own line in 2001. Her illustration clients include *Vogue*, *InStyle*, and Kate Spade. She recently finished the book *The Perfectly Imperfect Home* for *Domino* magazine founder Deborah Needleman. More of the artist's work can be found at www.virginiajohnson.com.

ANNA EMILIA LAITINEN was born in the countryside outside the small village of Leppävirta, Finland. She studied graphic design in Finland and Iceland, devoting her studies primarily to illustration. During her years in Iceland, she began to paint with watercolors, exploring the themes of landscape, nature, and the human form—and the intermixing of these elements. Since 2008 she has been living in Tampere, Finland. She works on illustrations and private commissions, painting stories from nature as it is found throughout the world. More of her work can be found on her website, www.annaemilia.com.

DAIRE LYNCH is a Dublin-born artist who currently resides in Cong, County Mayo, in the west of Ireland.

He is primarily a self-taught painter. His two main passions are art and music; he is also a sound engineer and a multi-instrumentalist. His work is in private collections throughout the world, including Australia, France, Germany, New Zealand, Scotland, and the United States. More of his art can be seen on his website, www.dairelynch.com.

FABRICE MOIREAU is a graduate of the École Nationale Supérieure des Arts Appliqués et des Métiers d'Art in Paris. He makes his home in France's Loire Valley, which has been featured in many of his watercolor depictions. He has published several of his sketchbooks, which feature watercolor cityscapes and landscapes of France, Italy, and other places. He has also illustrated books about food and cooking. More of his work can be found on his publisher's website, www.leseditionsdupacifique.com.

JANE MOUNT is an artist and illustrator, born in Atlanta, Georgia, and "formed" in Manhattan. In past incarnations she has studied anthropology, cofounded three companies, and won awards for her graphic and interior design skills. She is now living in Northern California. Her *Ideal Bookshelf* series, made up of more than four hundred works, can be seen on the website www.idealbookshelf.com.

AMY PARK loves architecture and building materials. She works exclusively in watercolor and pushes the medium beyond its usual constraints through her use of large-scale and hard-edged, geometric compositions. Her subject matter includes both architecture and abstractions, as well as what lies between the two. Park holds BFA and MFA degrees from the University of Wisconsin–Madison. She has had numerous solo and group exhibitions at the following spaces: Morgan Lehman Gallery (New York, New York), Project Row Houses (Houston, Texas), College of DuPage (Glen Ellyn, Illinois), and the Poor Farm (Manawa, Wisconsin). She was a recipient of a Marie Walsh Sharpe Space Program Residency in 2007–2008. Her most recent solo exhibition was held at Kopeikin Gallery in Los Angeles, California. Park lives and works with her partner, the artist Paul Villinski, alongside their son, Lark, in Long Island City, New York. More of her artwork is on display on her website, www.amypark.us.

Los Angeles–based artist and freelance illustrator **CATE PARR** was born in Shropshire, England, where she studied art at Shrewsbury College of Arts and Technology and at the University of Leicester. She additionally studied life drawing at Santa Monica College in California. More of her work can be seen on her website, www.cateparr.com.

ISADORA REIMÃO was born in the countryside of Piraju, near São Paulo, Brazil. Her parents encouraged her to pursue an artistic career; her father, also an artist, provided support and resources to develop her drawing and sculpting skills. She has since worked in both two- and three-dimensional art forms. One of her largest pieces was for a samba school, developing costumes, giant sculptures, and puppets. Her most recent work includes the art direction for the short film *Rubras Mariposas* (*Ruby Moths*), which premiered in January 2012. More of her art can be seen on her website, www.isadorareimao.com.br.

SUJEAN RIM was born in Brooklyn and grew up all over New York City. At an early age she discovered Charles Schulz's comic strip *Peanuts* and Ezra Jack Keats's children's book *The Snowy Day*; these works inspired her to become an artist. She attended the High School

of Art & Design in New York City, where her focus turned to fashion. After graduating from Parsons School of Design with a degree in fashion design, Rim began a successful career designing shoes and accessories for Perry Ellis, J.Crew, Ann Taylor, and American Eagle Outfitters. But her interest in art remained, and she found her first commission for her illustrations from Barney's New York—a small ad for the *New York Times*. Well-known for her work that appeared on the popular email newsletter *Daily Candy*, Rim has since partnered with many other clients, including Tiffany & Co. and Target. Today she is also a published author and illustrator of children's books, and she is working on several projects, including a campaign for UNAIDS. Rim lives in New York with her favorite artist—her husband, Bob—and their son, Charlie. More of her art is on display on her website, www.sujeanrim.com.

AMY ROSS lives and works in Boston, Massachusetts. She received her BA in religious studies from Connecticut College, followed by an MTS from Harvard Divinity School. She later studied studio art at the School of the Museum of Fine Arts, Boston, and has been exhibiting her paintings, drawings, collages, and wall murals since 2000. Her work has recently been shown in solo exhibitions at Kopeikin Gallery in Los Angeles, Steven Zevitas Gallery in Boston, and Jen Bekman Gallery in New York. She has also shown in group exhibitions at Danese Gallery in New York; the DeCordova Museum in Lincoln, Massachusetts; the North Dakota Museum of Art in Grand Forks; and the Steven F. Austin State University in Nacogdoches, Texas. More of her work is shown on her website, www.amyross.com.

JOSÉ SELIGSON was born in Mexico City. He studied at the Universidad Nacional Autónoma de México, with additional art studies in Mexico and the United States. His work has been exhibited throughout the world, including solo shows at, most recently, Galería CDI in Mexico City and Graphic Eye Gallery in Port Jefferson, New York. His work is also held in numerous private collections in Argentina, Canada, Colombia, Croatia, England, Germany, Israel, Mexico, Romania, the United States, and Venezuela. His work is displayed on a page of the Saatchi online gallery: www.saatchionline .com/BLDRDSH.

BECCA STADTLANDER was born and raised in Covington, Kentucky. She received a BFA in illustration from the Maryland Institute College of Art, and she currently works as a freelance illustrator. Her clients include: *O, The Oprah Magazine*, Little Otsu, Red Cap Cards, YETI Publishing, Brown Publishing, *Annalemma* magazine, *Selvedge, Oh Comely* magazine, and *Oxford American* magazine. Her work has been featured in the *Society of Illustrators Annual*; *3×3, The Magazine of Contemporary Illustration*; and many other art and illustration publications in the United States and Europe. Stadtlander lives and works in Kentucky. To see more of her pieces, visit www.beccastadtlander.com.

JOHN NORMAN STEWART was born in San Bernardino, California, and raised in the Los Angeles area. He studied with the Famous Artists School and received a scholarship to the Chouinard Art Institute; he later attended the Art Center School (now called the Art Center College of Design) in Los Angeles. He had a career as a scenic and portrait artist for the entertainment industry with projects

for television, motion picture, and stage productions. He also undertook special art projects for Disney Studios, Disneyland, Disney World, Epcot, and Animal Kingdom. He is a signature member of the National Watercolor Society, a past member of the Los Angeles Art Association, and a past member of the California Art Club. His work has been exhibited extensively in the United States. More of his work can be seen on his website, www.johnnormanstewart.com.

Born in Piacenza, Italy, **PAOLO TERDICH** has traveled widely and lived in various countries, including the United Kingdom, the Netherlands, Egypt, and Nigeria. His paintings, influenced by these travels, span many genres, including figurative, portraiture, landscape, and still life. His most recent series, *Waters*, integrates complex compositions with figurative subjects. His work is held in many institutions and galleries, and he has exhibited throughout the world. For more of his artwork, visit www.paoloterdich.it.

TAMARA THOMSEN reimmersed herself in artwork full-time after a two-decades job at a New York design firm. She studied painting in school, obtaining a BFA from Syracuse University and an MFA from Virginia Commonwealth University. Recent group exhibitions include *The New Intimists* at NURTUREart and the *Brooklyn Navy Yard Artists Group Exhibition*, both in Brooklyn, New York. Her work is available as archival limited-edition prints at www.20×200.com, as well as on her website, www.tamarathomsen.com.

JENNY VORWALLER is a primarily self-taught artist; she lives and works in Seattle, Washington. She has studied in Italy, and she now makes her art a part of her daily life that she shares with her husband and two small sons. Vorwaller's creations can be found in private collections throughout the world and on her website, www.jennyvorwaller.com.

HANNAH WARD was born and raised in upstate New York; she received her BFA in painting and drawing from the State University of New York at New Paltz. Her body of work includes highly detailed drawings, paintings, installations, and collage. For more of her art, see www.hannahwardstudio.com.

Resources

A SELECTED LIST OF RESOURCES ABOUT
WATERCOLOR ART.

Marian Appellof. *Everything You Ever Wanted to Know About Watercolor*. Watson-Guptill, 1992.

Moira Clinch. *The Watercolor Painter's Pocket Palette*. North Light Books, 1991.

Hazel Harrison and Diana Craig. *The Encyclopedia of Watercolor Techniques: A Step-by-Step Visual Directory, with an Inspirational Gallery of Finished Works* (Second Edition). Running Press Books, 1999.

Nita Engle. *How to Make a Watercolor Paint Itself: Experimental Techniques for Achieving Realistic Effects*. Watson-Guptill, 2007.

Christopher Finch. *American Watercolors*. Abbeville Press, 1991.

Christopher Finch. *19th-Century Watercolors*. Abbeville Press, 1991.

Christopher Finch. *Twentieth-Century Watercolors*. Abbeville Press, 1988.

Joe Garcia. *The Watercolor Bible: A Painter's Complete Guide*. North Light Books, 2005.

Jan Hart. *The Watercolor Artist's Guide to Exceptional Color*. Walter Foster, 2007.

Cathy Johnson. *Creating Textures in Watercolor: A Guide to Painting 83 Textures from Grass to Glass to Tree Bark to Fur*. North Light Books, 1999.

Heather Smith Jones. *Water Paper Paint: Exploring Creativity with Watercolor and Mixed Media*. Quarry Books, 2011.

Charles Le Clair. *The Art of Watercolor* (Revised and Expanded Edition). Watson-Guptill, 1999.

Gordon MacKenzie. *The Complete Watercolorist's Essential Notebook: A Treasury of Watercolor Secrets Discovered through Decades of Painting and Experimentation*. North Light Books, 2010.

Ralph Mayer. *The Artist's Handbook of Materials and Techniques* (Fifth Edition). Viking, 1991.

Colette Pitcher. *Watercolor Painting for Dummies*. John Wiley & Sons, 2008.

William F. Powell. *Color Mixing Recipes for Watercolor: Mixing Recipes for more than 450 Color Combinations*. Walter Foster, 2007.

Don Rankin. *Watercolor Glazing Techniques*. Watson-Guptill, 1991.

Patricia Seligman. *The Watercolor Artist's Flower Handbook: Leading Floral Artists Show How to Capture the Beauty of Flowers*. Watson-Guptill, 2005.

Pip Seymour. *Watercolor Painting: A Handbook for Artists*. Lee Press, 1997.

Ian Sidaway. *The Watercolor Artist's Paper Directory*. North Light Books, 2000.

Joseph Stoddard and Brenda Swenson. *Watercolor Postcards: A Portable Studio*. Chronicle Books, 2011.

Jacques Turner. *Brushes: A Handbook for Artists and Artisans*. Green Editorial, 1992.